IMAGES
of America

TALLADEGA
PATHWAYS TO THE PAST

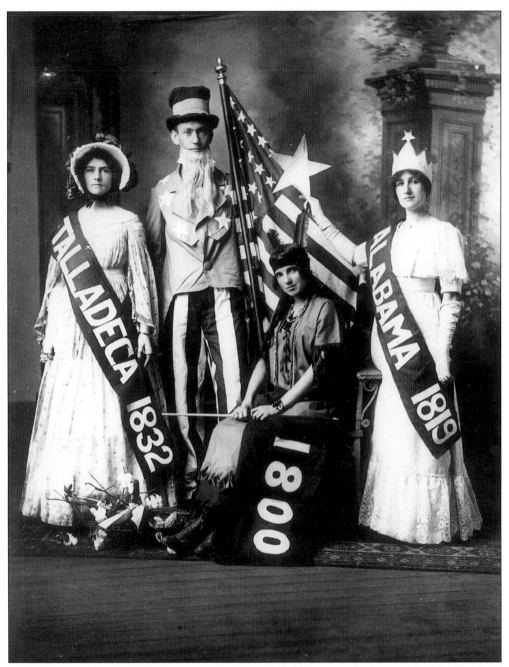

CENTENNIAL CELEBRATION, 1913. On November 7, 1913, a hundred years after the Battle of Talladega, the town celebrated its colorful history. In 1800, much of Alabama was still inhabited by Native Americans, and the area remained so for a number of years even after achieving state status in 1819. Talladega County was created in 1832, and the town of Talladega was incorporated in 1835. Pictured above from left to right are Mary Oliver, Hugh F. McElderry, Kathleen McElderry, and Lottie Slaughter.

IMAGES
of America

TALLADEGA
PATHWAYS TO THE PAST

Walter Belt White

ARCADIA

Published by Arcadia Publishing,
an imprint of Tempus Publishing, Inc.
2 Cumberland Street
Charleston, SC 29401

Printed in Great Britain.

Library of Congress Catalog Card Number: 2002106316

For all general information contact Arcadia Publishing at:
Telephone 843-853-2070
Fax 843-853-0044
E-Mail sales@arcadiapublishing.com

For customer service and orders:
Toll-Free 1-888-313-2665

Visit us on the internet at http://www.arcadiapublishing.com

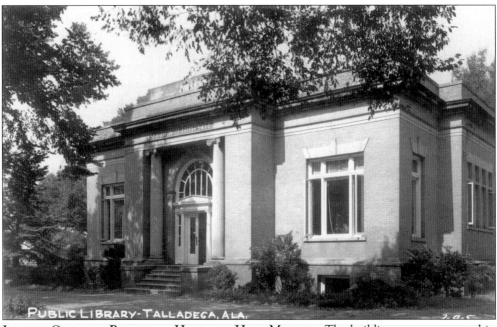

JEMISON-CARNEGIE BUILDING—HERITAGE HALL MUSEUM. The building was constructed in 1908 and was the site of the town's first public library. Mrs. Lou McElderry Jemison was the founder, having donated the lot and $10,000 for its erection. Now serving as Heritage Hall Museum for arts and history, it is one of four remaining Carnegie library buildings in Alabama. The museum is sponsor of *Talladega: Pathways to the Past.*

CONTENTS

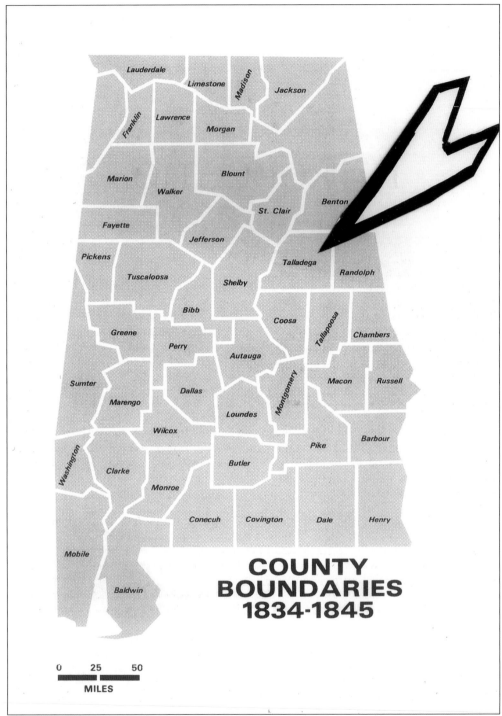

ALABAMA COUNTIES, 1834–1845. On December 18, 1832, the Alabama legislature created nine counties out of areas in the Creek Indian Territory. Talladega County, located in the east central part of the state, was among them. It originally included land that would be made into Clay County in l866. Talladega became the county seat in l835.

INTRODUCTION

Talladega. What images come to mind when you hear the name? Many probably envision a super raceway, with stockcars whizzing around at breakneck speeds. Others perhaps visualize nearby Cheaha State Park, DeSoto Caverns, the Talladega National Forest, Logan Martin Lake, antique shops, the recently restored Ritz Theater, or the famous Purefoy Hotel of a bygone era. The institutionally minded may think of the Alabama Institute for the Deaf and Blind, Talladega College, the Presbyterian Home for Children, Shocco Springs Baptist Conference Center, or the Federal Correctional Institution. Others may picture historic buildings and lovely old homes, showcased annually during the April in Talladega Pilgrimage. For many locals, thoughts may simply turn to family, friends, school, church, and daily life in small-town Alabama.

In 1835, when Talladega was incorporated, people of the area perhaps thought of Native Americans; the battleground where Andrew Jackson and Davy Crockett had fought; and the Big Spring, the center of town activity. Long before white pioneers moved in, the area was inhabited by Native Americans, most notably the Muskogee or Creek Indians. Their lifestyle included fishing with bows and arrows, hunting with blowguns, planting corn, and observing daily celebrations. Their name for the village, "Talatigi," was derived from two words, "talwa," meaning town, and "atigi," meaning border. The old Indian village was near a tribal boundary line. Gradually, whites moving into the area changed the pronunciation and spelling to Talladega.

In the early 1800s, trouble began when traders and squatters migrated into the Creek Territory. From 1813 to 1814, a full-fledged war was fought with the whites and friendly Creeks on one side and the hostile Creeks or Red Sticks on the other. The Battle of Talladega, part of the larger conflict, was won by the settlers and their allies, as was the war itself. Nevertheless, the area remained Creek territory until the signing of the Treaty of Cussetta in the spring of 1832. Even after the creation of Talladega County in December of 1832, Indians remained in the area, though most were removed on the Trail of Tears in 1836, the year following Talladega's incorporation.

By terms of the Treaty of Cussetta, a half section of land was given to "Joseph Bruner, a colored man," for his services as an interpreter. This half section included what became most of downtown, about half of Talladega College, all of the School for the Deaf, Oak Hill Cemetery, and the cotton mills. As blacks were not normally allowed to own real estate, Talladega was perhaps the only town in North America in 1832 owned by an African American.

However, Bruner soon sold the land to Jesse Duran and other investors. These men divided the section into plots, added more land, and sold lots to make the "white man's town." Seven streets—North, South, East, West, Court, Spring, and Coffee—were laid out, each with a width of 30 feet. Battle Street, also known as Broad Street and Main Street, was wider.

Within a short while, log houses, taverns, trading posts, hotels, and churches were

constructed. By a margin of one vote, the Battleground (Talladega) was selected as the site for the county courthouse. In February 1836, a special tax for erecting the building was placed on various items, including racetracks, race horses, billiard tables, and playing cards. (Do you suppose gambling might have been a favorite pastime of the pioneers?) The courthouse was completed in 1838, and it remains "the oldest courthouse in continuous use in Alabama."

During the decades before the Civil War, Talladega continued to grow. The town received its fair share of merchants, doctors, lawyers, teachers, and preachers. Most area inhabitants were, of course, farmers, some of whom could be termed "planters." By 1860, 39 percent of the county population consisted of slaves. As the question of secession came to the forefront, Talladegans were about evenly divided. Following the outbreak of war the opposing factions united; a company of troops, known as the Talladega Rifles, was immediately organized.

In addition to supplying soldiers, Talladega provided uniforms, a nitre works, an instruction camp, a "Soldiers' Aid and Relief Association," a hospital for the wounded (in the Exchange Hotel), and a prison for federal soldiers (in the Baptist Male High School, later Swayne Hall of Talladega College). Concerts were held to benefit the wounded, and a "Battle Field Relief Association" was organized. Evening prayer meetings were rotated in the various churches.

On July 17, 1864, Talladega came in direct contact with the enemy. General Rousseau passed through the county moving south. Although the railroad depot was the only building burned and destroyed, almost every private residence in town was entered, with bacon, corn, oats, and horses being confiscated. Farmlands outside the town were burned. The next year, two weeks after Lee's surrender, the community was visited by Croxton's Raiders. This time more buildings were burned, and stores were robbed. The citizens lost many of their valuables. When threats were made to complete the burning of the town, Judge Thornton approached General Croxton and gave a Masonic sign. He asked him to have mercy on the community and is credited with saving the village from total destruction.

As in other parts of the South, post-war times were difficult—so difficult that many moved away, often to the West. Those who remained struggled to eek out a living, mostly through farming. Gradually the development of iron mines, marble quarries, and textile mills helped stimulate the economy. By 1885, the economic situation had improved, but the town still had the reputation of being a lawless community. Outsiders frequently came to town, riding their horses on the sidewalks, shooting their pistols, and terrorizing peaceable citizens. At that time William H. Skaggs, a young man of 23, was elected mayor. A new police force was installed, arrests were made, fines were imposed, and the situation was brought under control. During his three terms as mayor, Skaggs brought about numerous reforms and improvements, and overcame strong opposition in the process. Streets were improved, stone curbing was put in place, and sidewalks were laid. A fireproof warehouse was constructed, trees were planted on the square, a water works was built, and a new prison was erected. Perhaps most importantly, a public school system was established.

During the following century, Talladega continued to make progress. Textile mills, foundries, and other plants were built. An entire community, Bemiston, grew up around the Bemis Bag Company. The Brecon area, with the creation of wartime plants, "mushroomed" during World War II. With the growing population, additional schools were built and more churches were organized. Likewise, new opportunities for recreation and entertainment appeared.

During the last half of the 20th century, other social and economic changes occurred. With the Civil Rights era, the town gradually became accepting of other races. With the coming of shopping centers and chain stores, consumers benefited and many found employment; however, locally owned drug, grocery, hardware, and general merchandise stores were hurt. In fact, some such stores were forced to close. In the process, the town lost some solid citizens and valuable civic leadership. Nevertheless, with the coming of new industries, the continued success of varied institutions, and renewed community pride, the town has rebounded. Drawing on its rich heritage, Talladega looks toward a bright future.

One
INDIAN TRAILS AND
PIONEER PATHS

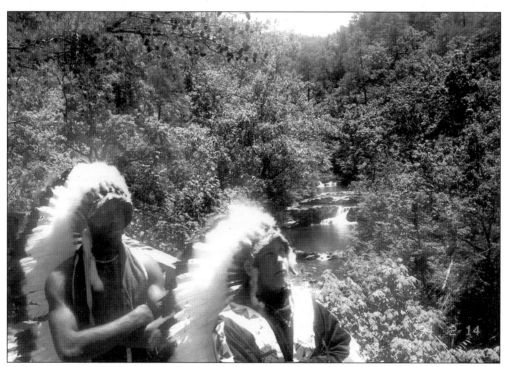

CHINNABEE SILENT TRAIL. Indian trails existed in the Talladega area for centuries before white men blazed new pathways. In the 1970s, the "Silent Warrior" scout troop of the Alabama School for the Deaf constructed this trail leading from Lake Chinnabee—a reminder that Muskogee paths led to and from waterways. The Muskogees of East Alabama were in fact called "Creeks" by the settlers, for they tended to live along streams and rivers. Pictured are modern-day ASD "Silent Warriors" Frankie McClendon (left) and C.J. Hill (right).

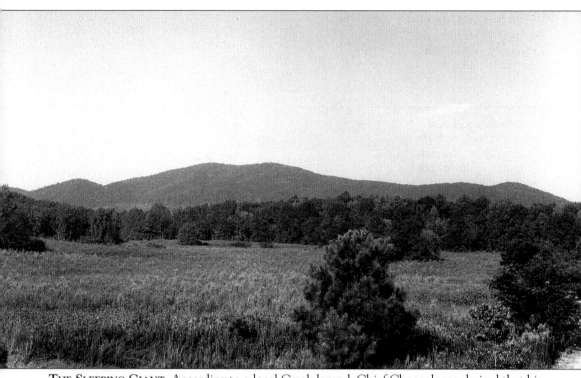

THE SLEEPING GIANT. According to a local Creek legend, Chief Choccolocco desired that his only daughter, Princess Talladega, marry the prosperous Chief Cheaha. Talladega, however, had fallen in love with a handsome but poor brave, Coosa, who also loved her. To eliminate the competition, Cheaha had a drug administered to Coosa that would keep him sleeping indefinitely. When Talladega learned that Coosa would never awaken, she disappeared on the day of her wedding to Cheaha, only to be discovered lying dead on the breast of her lover. Although the drug was so powerful it kept Coosa always sleeping, it also carried the power to make him grow. Throughout the centuries, he has continued to grow, forming the mountain pictured above. Lying between Plantersville and Renfroe, he still dreams of his beloved Talladega, "The Bride of the Mountain."

CREEK INDIAN BALL GAME. All Southeastern Indians, including the Creeks, played ball games. Balls were made of deerskin stuffed with animal hair. Using wooden sticks with a deerskin loop at one end, players tried to throw the ball between two goal posts or to hit one of the posts with the ball. With few rules, the game was for the most part "every man for himself." This style of play resulted in frequent injuries, and sometimes death. The game was so brutal that it was at times substituted for war. (Drawing by Tommy Moorehead.)

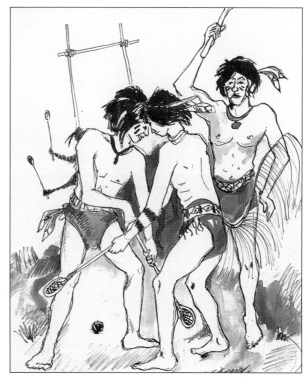

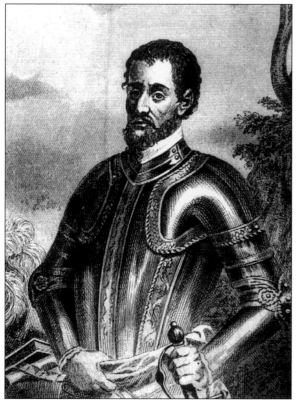

HERNANDO DESOTO. The first white man on record to visit the Talladega area was DeSoto in July 1540. Tradition holds that he spent the night at Shocco Springs, where he was fascinated by its waters. When his interpreter Juan Ortiz became ill at Coosa (near present Childersburg), he sent back to Shocco for its waters, which cured him. When DeSoto departed, a black man named Robles and a Spaniard named Freyada remained, thereby becoming the first two non-Native Americans to permanently settle in Alabama.

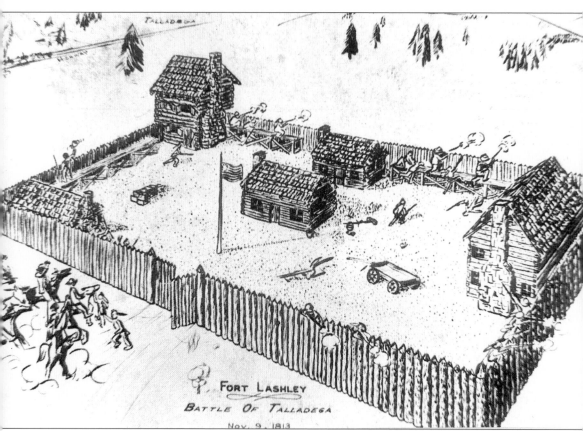

FORT LASHLEY
BATTLE OF TALLADEGA
Nov. 9, 1813

BATTLE OF TALLADEGA. As squatters and traders moved into frontier areas following the American Revolution, the Native Americans, including the Muskogees (or Creeks) in Alabama, were divided on the question of white settlement. A larger group, encouraged by the British, opposed infiltration and invasion of their land. A smaller group, desiring peace and trade, favored cooperation. After feelings intensified and hostilities began, Talladega became the scene of a major conflict. Before the battle, approximately 17 settlers and 120 friendly Creeks gathered inside a fort that had been constructed around the home of Alexander Leslie (or Lashley). The home was on a hill on the east side of what is now the Talladega-Sylacauga Highway, about one mile from Court Square. Soon it was surrounded by 1,081 hostile Creeks or Red Sticks. The situation seemed to suggest impending disaster.

ANDREW JACKSON. At the time trouble was brewing in Talladega, Andrew Jackson was encamped at Fort Strother, located at Ten Islands on the west side of the Coosa River about 30 miles from Talladega. After a courier arrived at Fort Strother with a report on Talladega, Jackson prepared his men for battle. The following day, November 8, 1813, he and his volunteers marched 24 miles, camping within six miles of Fort Leslie (Lashley).

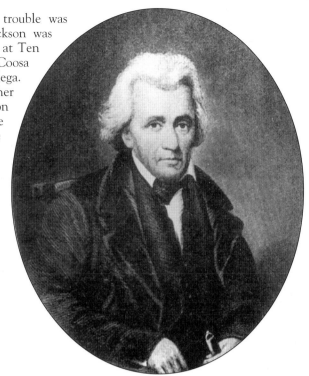

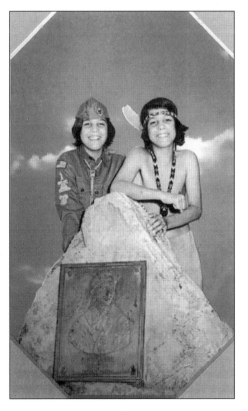

SELOCTA MONUMENT. The courier who reached Jackson with the call for help was perhaps Selocta, the son of Chinnabee, a major ally of the whites. According to tradition, Selocta (a well-known scout) donned a pig skin, "rooted around," escaped past the besieging line, and made his way to Fort Strother. It was his message that prompted Jackson to move immediately toward Talladega. The 1970s scouts at Selocta's gravestone are twins Jon Adams (left) and Jeff Adams (right).

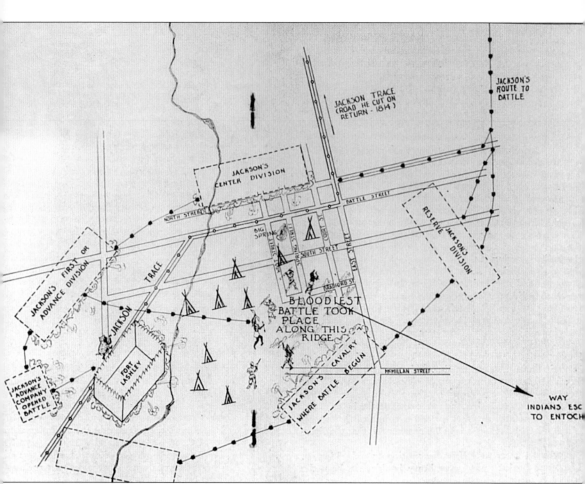

THE BATTLE PLAN. Rising early on the morning of November 9, Jackson and his army began the six-mile trek to Talladega. In only a short time, they were within a mile of the enemy. Here, just above the present municipal golf course, they had breakfast and discussed the plan of battle. By 8 a.m., Jackson was within 80 yards of the enemy. He had instructed his men to arrange themselves in a crescent shape. Then, luring the hostile Indians into the crescent, his army was to close ranks, encircling them. Lieutenant Bradley, however, failed to follow the plan. A gap was left, and through it a number of Indians escaped. Nevertheless, 299 Indians fell on the field of battle, while only 15 whites perished during the struggle (with two others later dying from wounds received). The Battle of Talladega was thus a great victory for the whites and their Creek allies.

14

DAVY CROCKETT. Davy Crockett, "King of the Wild Frontier," was among the 3,500 volunteers who were with Jackson. An account of his part in the Battle of Talladega is given in his autobiography. Recent evidence supports the claim that the autobiography was actually ghost written by Thomas Chilton, formerly a congressman from Kentucky, who at the time of the book's publishing was pastor of the Good Hope Baptist Church in Talladega (now First Baptist).

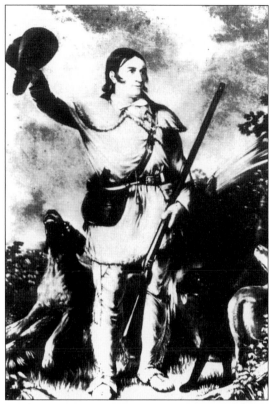

"PIONEERS OF THE WILDERNESS." This float, part of the 1913 centennial celebration of the Battle of Talladega, commemorated the arrival of the early settlers. For almost 20 years after the Creek War, the region remained Creek Territory and was predominantly populated by Indians and a few traders and squatters. Then, following the signing of the Treaty of Cusetta and the creation of Talladega County in 1832, more settlers began moving in, and "white man's Talladega Town" was founded.

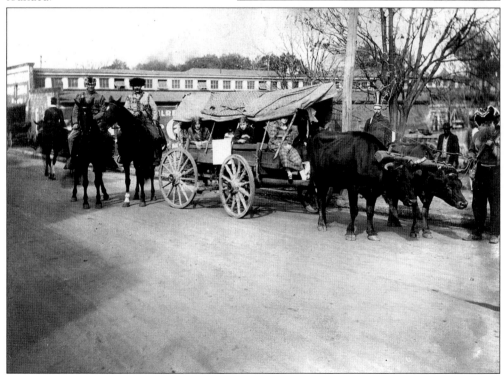

THE BIG SPRING. In Talladega's earliest days, the Big Spring was the town center. It was located at the corner of present Spring and West Battle Streets, along the original McIntosh Trail. Looking east toward the square, the viewer sees on the right the Able and Upton Tavern. It was built of logs and had the town's first chimney. Across is lawyer J.H. Townsend's blacksmith shop. (Research and painting by Frances Sweat Upchurch.)

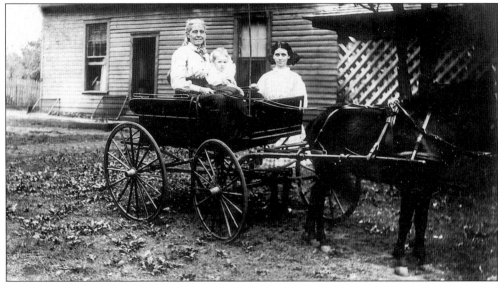

HORSE AND BUGGY DAYS. Bringing their belongings in saddlebags, early pioneers of Talladega County probably came on horseback over some Indian trail. Later, the trails were widened so that wagons and carts might bring food and furnishings. The "horse and buggy days" (or perhaps more appropriately "wagon days") remained for a very long time. Pictured in 1910 are Mrs. R.L. Stringer (Rena McMillan) and daughters Frances (in wagon) and Annie Laurie (standing).

STARTING POINT OF TRAIL OF TEARS. Following the surrender of the Creeks, and the signing of the Treaty of Cusseta in April of 1832, the Indians were marched to western territories over the Trail of Tears. In the autumn of 1836, a group of 3,490 Indians from the former Creek Territory was assembled near the Reece Howell family home pictured here. J.M. Douglas, who as a small child lived nearby, later recalled there was "a great fear the Indians would revolt, overpower the soldiers, and take their guns and kill and wound the people." A false alarm was given that rebellion had indeed broken out. The people in Talladega panicked, anxiously preparing to defend the community. Soon, however, the report was dispelled. Shortly thereafter, the Indians were moved from Howell's Cove to the territory west of the Mississippi River, many dying along the way.

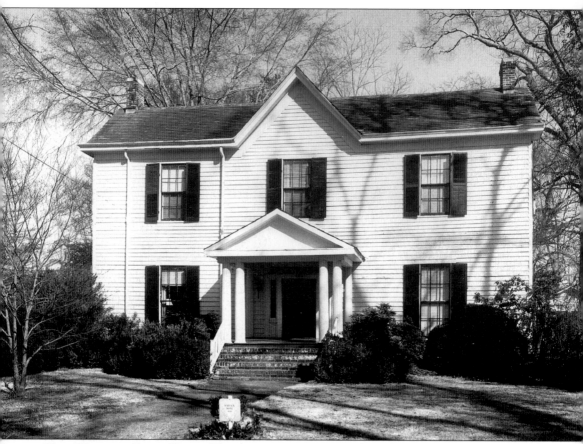

THE WARWICK-PAUL HOME. This house was constructed in the 1830s on the road that eventually became East Street. Pioneer lawyer Simeon Douglas, one of the commissioners to oversee the building of the courthouse, built this house with its unusual history. After Douglas, later residents included at least one lawyer, judge, newspaper editor, court justice, mayor, senator, congressman, banker, and preacher. Among the notables was attorney A.J. Walker, an author of the Alabama Code, who twice served as Chief Justice of the Alabama State Supreme Court. In 1882, the house was purchased by a Mrs. Cowan, who died in 1908. The property was willed to her two grandsons, W. Frazier and Dr. B.B. Warwick. Each wanted to buy the other's half-interest, but neither would sell. An agreement was reached. The house was sawed in two, pieces were pulled apart, and two houses were made! The house pictured, owned by Dr. Warwick, had certain additions fashioned. The rear section of the original house was moved to the next lot, where it was made into a one-story. The Warwick home remained in the family for over a century. It is now owned by Dr. Rob Paul and his wife Melanie.

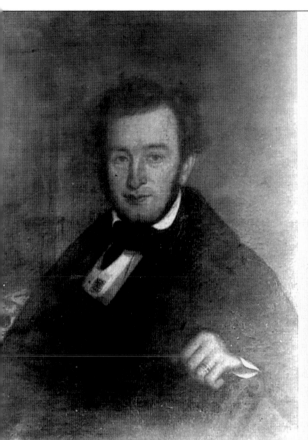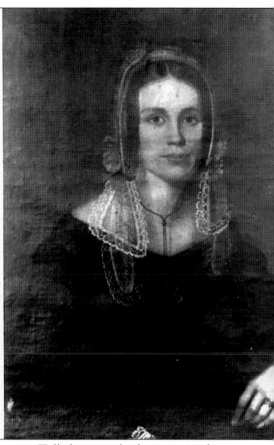

THOMAS AND KEZIAH WARWICK. The Warwick story in Talladega goes back to pioneer days, when Dr. B.B. Warwick's grandparents entered the area. Thomas and Keziah, natives of Coventry, England, married in 1831 and came to America in 1833. In 1847, they were living in Mobile. Finding the climate there unsatisfactory, they headed by wagon for Virginia. While camped at Nine Mile Camp, Mrs. Warwick had the misfortune of breaking her ankle, necessitating a stay of some days. During this time, the couple fell in love with the Alabama mountains, and they decided to make this area home. Soon they were residing on the corner of Coffee and East Streets in Talladega. In September of 1847, Warwick, a watchmaker and jeweler, opened his business on the north side of the town square. During the Civil War, Croxton's Raiders forcibly carried off stock and cash—including gold watches, silver, and gold in bulk, and $9,000—amounting to a total value of over $20,000. As a British citizen, Warwick petitioned the United States government, asking that justice be done. Unfortunately, his efforts to collect damages were not successful. Nevertheless, he remained a faithful Talladegan, and his family was represented in the city until near the end of the 20th century.

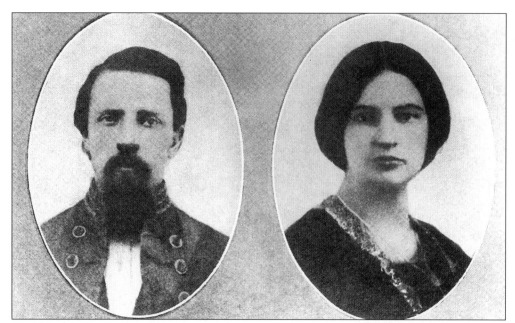

FIRST MALE WHITE CHILD. George Knox Miller was the first white male child born in Talladega. Pictured here with his wife, the former Celestine McCaan, he was born December 30, l836, in the house now known as Whitwood (which at the time was a small cabin). A captain in the Confederate army, he frequently wrote letters home, and these are currently being edited for publication. He later served as probate judge, mayor, and editor of *Our Mountain Home*.

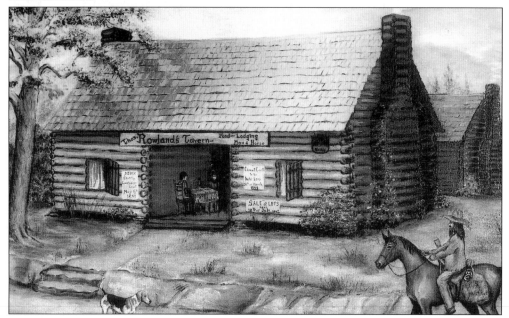

ROWLAND'S TAVERN. Located on the McIntosh Trail, on the present southwest corner of West and West Battle Streets, the tavern was the first known structure in Talladega. Mail was delivered here, and it was the site of all county business. The Presbyterians organized and met here in 1834. (Research and painting by Frances Sweat Upchurch.)

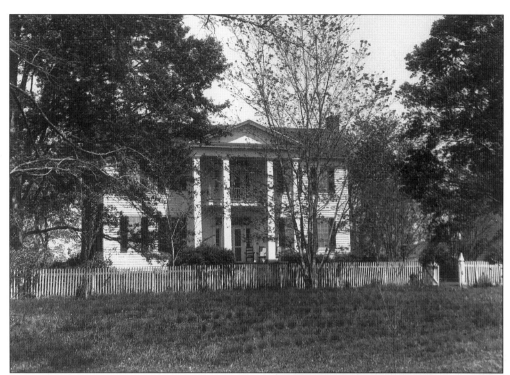

THORNHILL. Although most settlers lived in log cabins or humble farmhouses, a few built plantation homes like Thornhill, situated on a 1,700-acre tract bordering Talladega Creek. The house was built by John Hardie, a native of Scotland, and his Virginia-born wife Mary Meade Hall Hardie. Entering the county in 1835, they were both known for their generous spirit and kind deeds. The phrase "Mary Meade Hardie Who Labored More For Others Than For Self" was inscribed in a beautiful stained-glass window in the First Presbyterian Church.

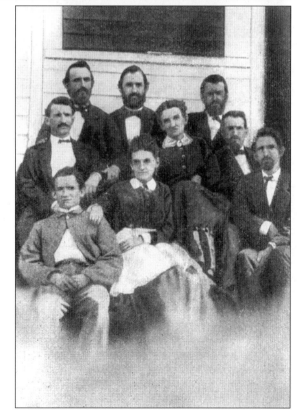

THE HARDIE CHILDREN. John Hardie and Mary Mead Hall were married in 1828 when she was about 16 years old. They became the parents of nine children—seven boys and two girls. Annie Elizabeth (second from left on first row) was an accomplished horsewoman: traces of a racetrack are still visible on the plantation. Six of the seven sons fought for the Confederacy.

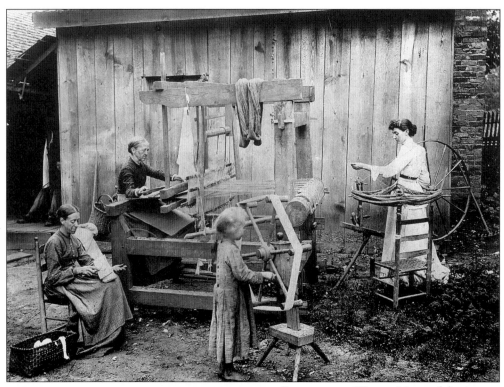

PIONEERS AT WORK. Many of the items needed by the pioneer household were made by family members. For instance, broom sedge was gathered by the armloads, tied into bundles, and stored in the smokehouse until needed for making brooms. Of course, as indicated here, spinning, weaving, and sewing were done at home.

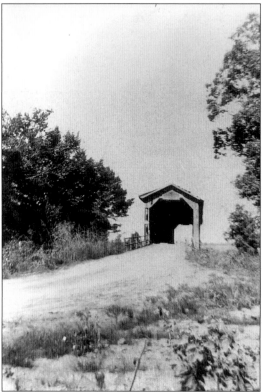

COVERED BRIDGE OVER CHEAHA CREEK. Early pioneers in the Talladega area were blessed with an abundance of small streams and creeks. However, the waterways could sometimes present a problem until the first bridge was built in 1835. The creeks could often be crossed only at certain points. After bridges were constructed, they were sometimes washed away during periods of heavy rain. Samuel Jemison (1820–1862) had this bridge built over Cheaha Creek just north of Sunnyside Cemetery and the Jemison home (now on Curry Station Road). It was built using round hickory pins rather than nails.

Two
COURT SQUARE, BUSINESS STREETS, AND INDUSTRIAL BOULEVARDS

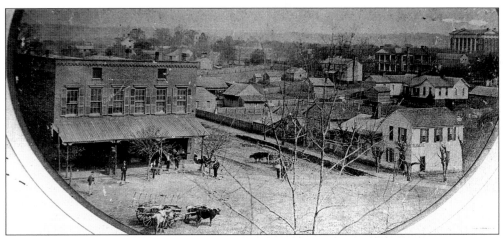

SOUTHEAST CORNER OF SQUARE, 1868. Not long after the founding of Talladega, the square became the town center. The large brick building on the left was J.B. McMillan & Co., built in 1866 following a fire that destroyed the frame buildings on the east side of the square. The white building on the right bears the sign "Bakery." In the distance is Manning Hall of the Alabama School for the Deaf, built in 1850–1851.

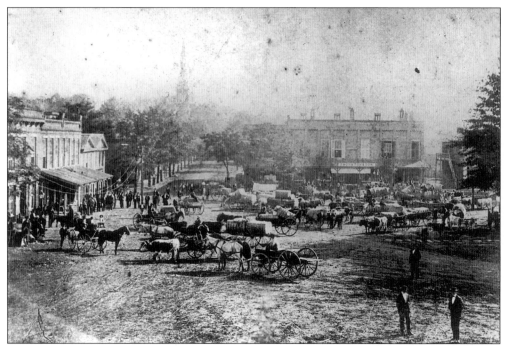

NORTHEAST CORNER OF SQUARE, 1873. Crowds gather for market day in downtown Talladega in this photograph. For years, Saturday was a day for trading and socializing on the square. The large building on the right bears the name "Thornton & Son." For most of the 20th century, it was referred to as "the hardware building." On the left, the store with the sidewalk shelter later became Henderson Drug Co. The steeple of First Presbyterian Church can be seen up North Street.

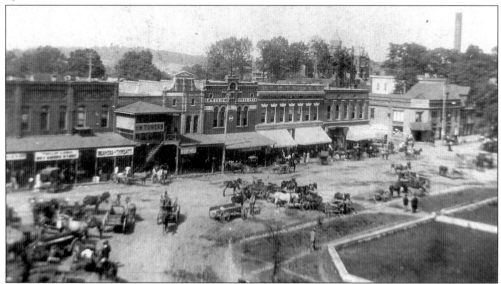

NORTH SIDE OF SQUARE, 1900. Stores line the north side of the square, today marked most noticeably by the restored Ritz Theater. At right is the "Isbell Brick Corner," and Isbell College can be seen at right on the hill. The tall standpipe was for Talladega's first water works. The block wall around the courthouse was constructed in 1899.

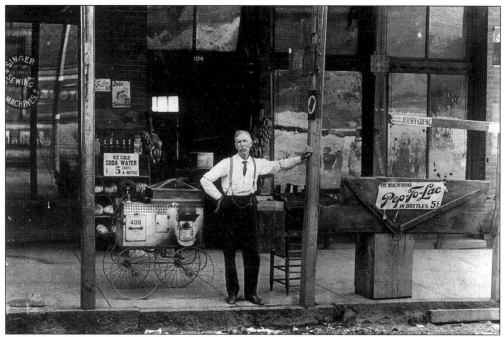

THE BAZAAR. The W.R. Hillsman store, located in the "triangle building" on the southeast corner of the square, was known as "The Bazaar." In the picture note the signs: "Singer Sewing Machines," "Ice Cold Soda Water," "Jersey Crème," and "The Health Drink: Pep-To-Lac in Bottles 5 cents." Also, notice the bananas hanging on each side of the doorway.

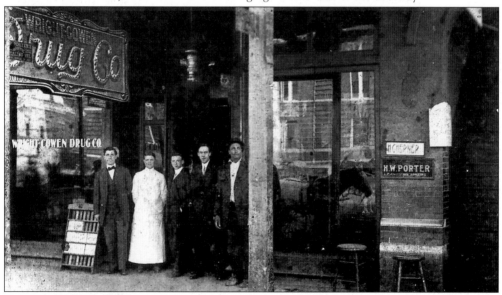

WRIGHT-COWEN DRUG CO. Located on the south side of the square, the business was established in 1889 by Louis J. Wright. Beginning in 1913, it was "Joiner-McDiarmit." From left to right are D.P. McDiarmit, Fred Giddens, unidentified, Manley Joiner, and Joe Jenkins. After 1923, Graham Wright, son of Louis J., operated Wright Drug Co., and his son Jack later ran the business. Jenkins worked in the business for years (and was famous in Talladega for his homemade ice cream). Virgil Chappell was likewise a "fixture" for a very long time.

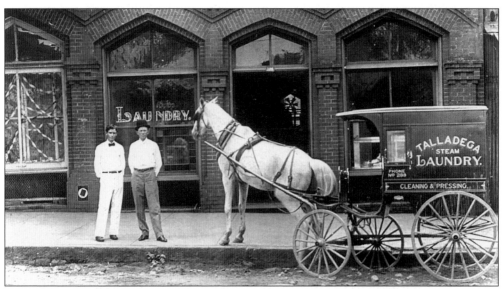

TALLADEGA STEAM LAUNDRY. Pictured in the early 1900s, the laundry was located on the south side of West Battle Street. The wagon states "Cleaning and Processing. Phone No. 289." Pick up and delivery were part of the laundry service.

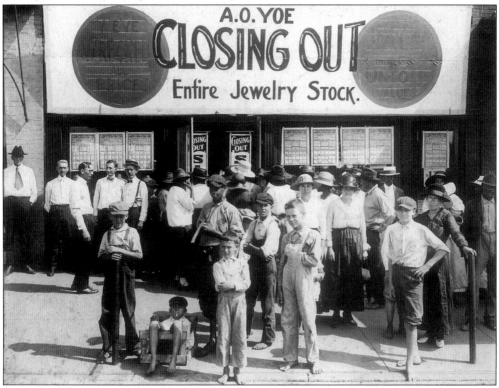

YOE CLOSE-OUT SALE. Business seemed to be booming when Dr. Alphus O. Yoe Sr. closed out his jewelry business in the 1930s. The business was located in the present Ritz Theater building. Dr. Yoe was also an optometrist and inventor, receiving several U.S. patents for devices relating to eyewear. One was for a "rocking nose piece" and another was for an adjustable bridge.

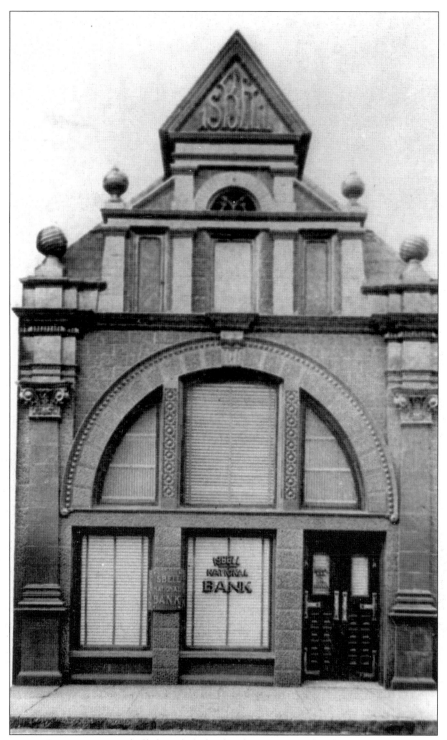

THE ISBELL BANK. James Isbell founded the bank in 1848. This building was completed in 1869. The bank underwent several name changes, and since 1978, it has been named "The First National Bank of Talladega." It is the oldest operating bank in Alabama.

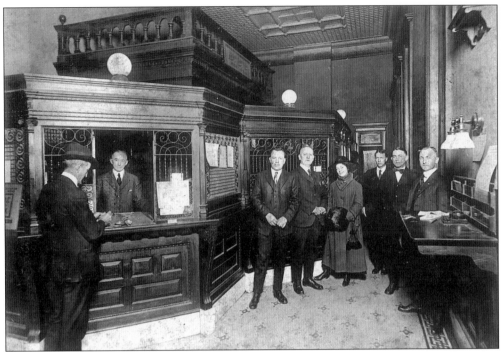

INTERIOR OF THE ISBELL BANK. Pictured above in formal attire are from left to right Ira Rhodes, Henry Lane, J.L. Chambers, James H. Ivey, Mrs. J.H. Ivey, A. Todd, Knox Camp, and Mont Lane.

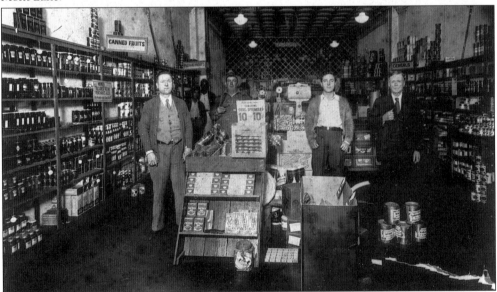

C.S. WEAVER & SONS. Charles S. Weaver, an early merchant, came to Talladega from Clay County on December 28,1897. He first operated a mercantile store on the south side of the square. In 1913, the store was moved to the north side and was known as C.S. Weaver & Sons. Pictured from left to right are his son Dewey, grandson William Malone, and C.S. Weaver. Since 1898, there has been a Weaver business on the square continuously. Robert Weaver's store is the oldest independently owned shoe store in Alabama.

STRINGER DEPARTMENT STORE. The R.L. Stringer Department Store was located on the square on the corner of East and North Streets. A 1907 newspaper ad listed over 100 items for sale for 10 cents, including pie plates, cake pans, fly traps, brooms, hand lanterns, coffee pots, and molasses pitchers.

HENDERSON DRUG CO. The Henderson Drug Co. was located on the north side of the square for many years. The store appeared on a listing of Talladega businesses in the 1887 "Alabama State Gazeteer and Business Directory" with S.H. Henderson as druggist. In this photograph made after the turn of the century, the three men at right (left to right) are Dr. B.B. Warwick, Bill Hurst, and S.H. Henderson. The "soda jerks" are unidentified.

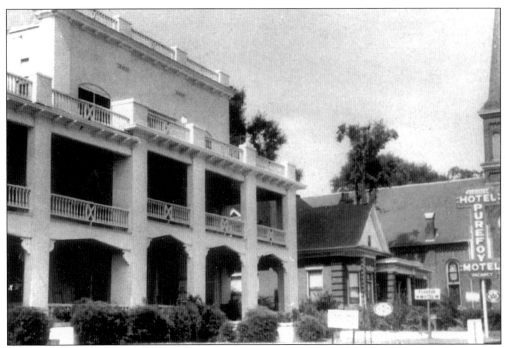

THE PUREFOY HOTEL. The Purefoy Hotel, located west of the First Presbyterian Church on North Street, was famous for its enormous array of delectable foods. Founded by Eva Brunson Purefoy and continued by her brother-in-law Ed Hyde, the hotel was known for both the abundance and quality of its food. Everything was "a specialty," and people came from miles away to sample the many dishes.

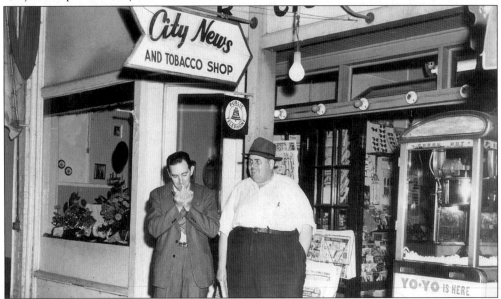

CITY NEWS AND TOBACCO SHOP. Earnest W. Hanna, owner of this shop on the east side of the square, is seen here with "Big Joe" Cassavant. Hanna had been a pianist with a traveling orchestra and performed in vaudeville. Cassavant was the son of Mrs. Lawrence O'Donavan and grandson of Judge Cecil Browne. (Photograph by R.E. "Buster" Hogan.)

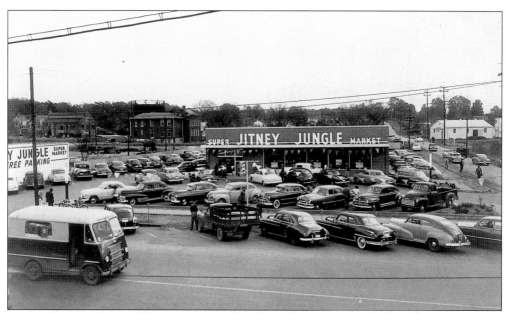

JITNEY JUNGLE. Located first on the south side of the square, Jitney Jungle was one of the earliest chain grocery stores to come to Talladega. Here, located on West Battle Street, it was one of the first large "off the square" groceries.

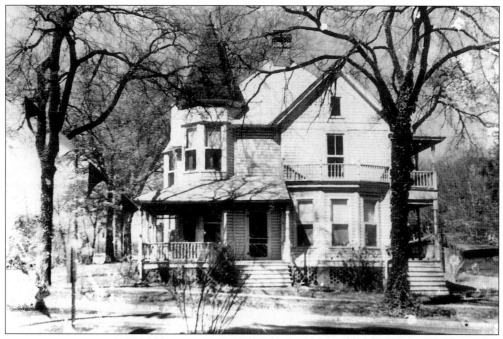

MISS NELLIE'S FIRST BOARDING HOUSE. The Hillsman home was built on the northwest corner of East and South Streets (now a vacant lot). Mrs. Nellie Ellis, niece of Mrs. Hillsman, opened her first dining room in this home. Later she operated a boarding house a block further south. Both food and fellowship were enjoyed at the ever-cheerful Miss Nellie's—and many a Talladega couple first met there.

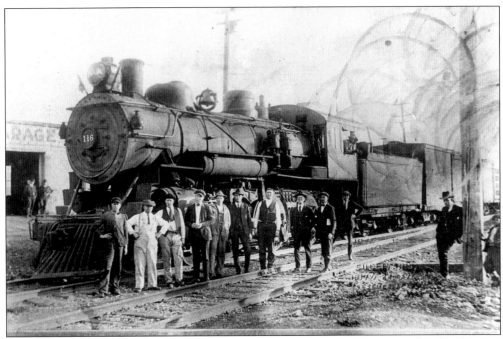

THE SOUTHERN RAILROAD. Railroads brought much business to town and railroads were themselves big business. At one time more than 20 passenger trains per day stopped in Talladega. Most young Talladegans today have never seen a passenger train.

WORKING ON THE RAILROAD. This crew seems to be having fun. In July 1902, the contracts were let for the construction of the Eastern Railway running from Talladega to Pyriton. The road covered a distance of 24 miles.

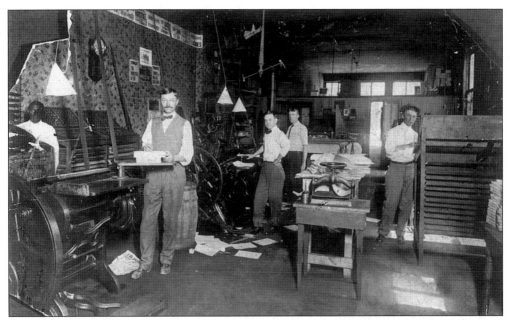

BRANNON PRINTING COMPANY. About the turn of the century, Billue and Brannon Printing Co. opened at 122 North East Street, just south of its present location. Later, Will R. Brannon bought W.T. Billue's interest, and his brother Lennis joined the firm. This 1912 interior view shows, from left to right, Dave Huey, W.R. Brannon, Joe Finegan, Morgan Bullard, and Lennis Brannon. The company is now owned by Mr. and Mrs. Cleve Jacobs.

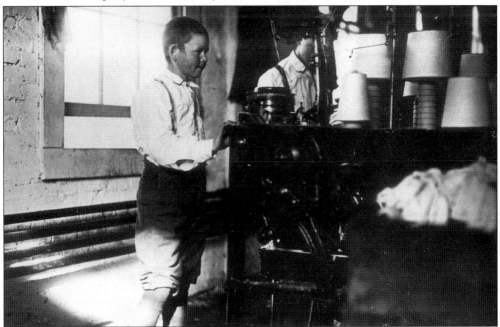

CHILD LABOR. With the growth of Alabama textile mills, the need for cheap labor grew. Child labor seemed to be a solution, but in reality, it created a major moral and health problem. Ministers and other reformers campaigned to end it; but despite laws restricting the practice, it continued into the 1930s.

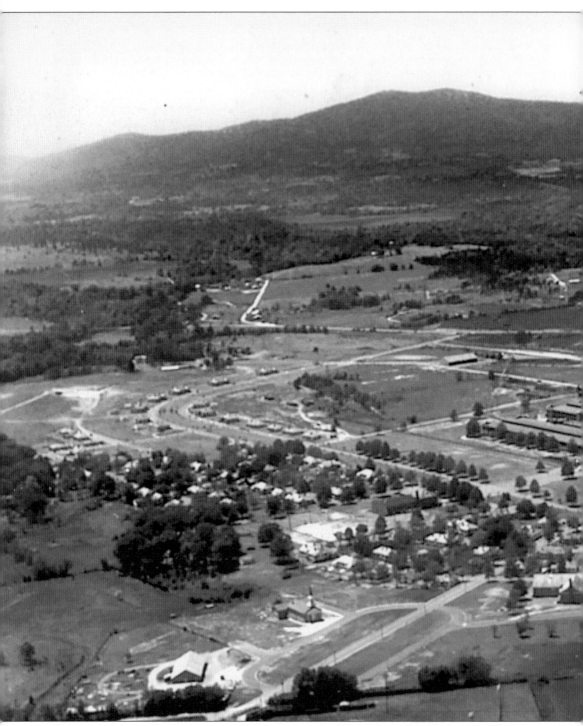

BEMISTON. A small community grew up around the Bemis Bros. Bag Company. The plant, started in 1928 and completed in 1929, produced "the best heavy duty bags" available, along with various twines. The community that sprang up included the mill, a modern dairy, a library, a school, a recreation center (which included a barber shop and a beauty shop), a store, service

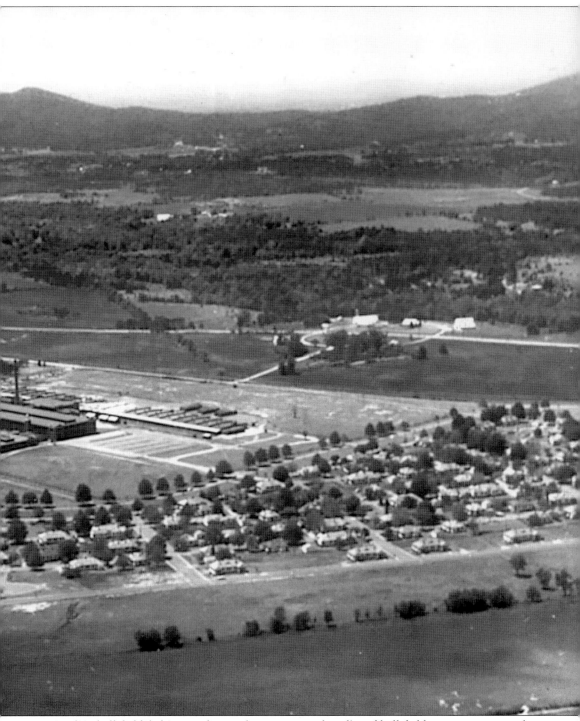

station, baseball field (where professional teams once played), softball field, tennis courts, and two churches. How many of these can you locate in the picture? In 1955, the community was annexed to the city of Talladega.

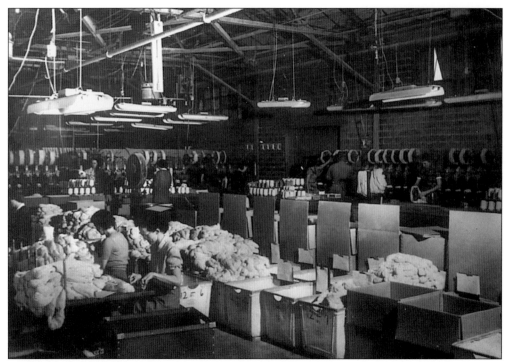

STRETCH TEX WORKERS. The Stretch Tex plant, located in Brecon, operated during the 1960s and 1970s. Textile workers have been busy in Talladega factories for many years. Much of the local economy has depended on the textile mills and their employees.

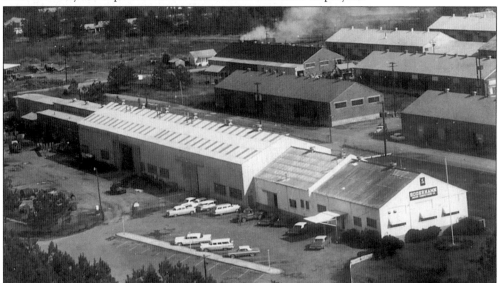

BRECON. The name *Brecon* was derived from the phrase By REquest of CONgress. The photograph shows businesses that subsequently occupied buildings constructed during World War II to house a munitions plant. In the foreground is Soderhamn Machinery Manufacturing Co., which built log debarkers, clippers, log hauling equipment, sawmill machinery, and logging equipment. Other businesses pictured include Syna-Flex Rubber Products, Talladega Machine & Supply Co., Weaver and Sons Sheet Metal, and Talladega Box and Pallet Company.

Three
RESIDENTIAL ROUTES

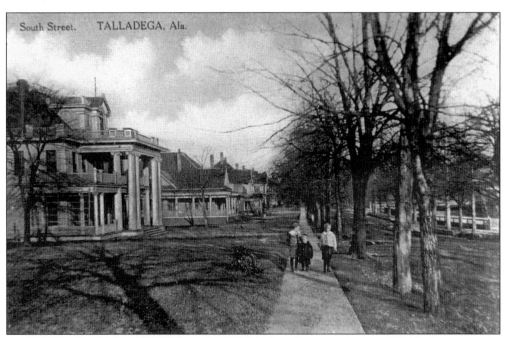

A STROLL DOWN SOUTH STREET. In 1906, sidewalks were laid on South Street to the Academy for the Blind. Walking, a major means of transportation, was thereby made much easier. The home in the left foreground was built between 1901 and 1904 by J.F. Reynolds, a cashier at Isbell National Bank. At one time, the house served as the manse for the First Presbyterian Church. Now named Dogwood, it is the home of Bill and Evelyn McGehee.

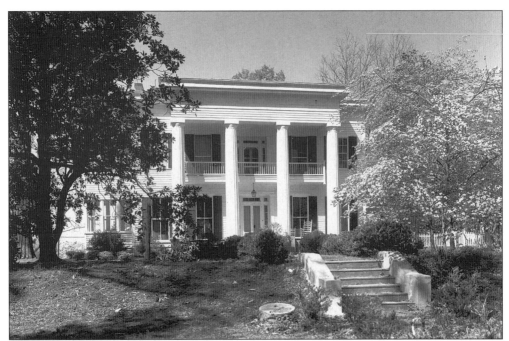

PLOWMAN-ELLIOTT-HEACOCK HOME. This East Street home was built between 1850 and 1853. Following the death of Idora McClellan Plowman Moore (author "Betsy Hamilton"), the house was sold and used as a boarding house until it was bought by Julian and Margaret Elliott, who restored it to its original splendor. In the 1980s, it underwent another restoration by its present owners, the Gary Heacock family. Like Dogwood, it is one of many lovely old homes in the historic Silk Stocking District.

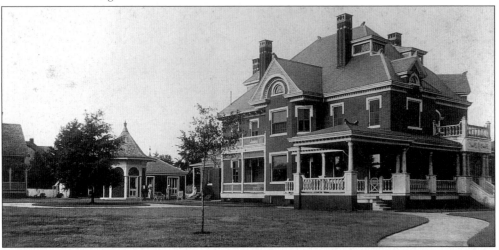

E.S. JEMISON-EVA B. PUREFOY HOME. After living in Texas and New York, the Jemisons returned to Talladega in 1895. He died the following year, and in 1898, Louisa built this home on the corner of South and Cherry Streets. She was a philanthropist, providing land and/or money for schools, a hospital, a nurses' home, a public park, a library, and churches. Later the home was purchased by Eva B. Purefoy, owner of the famous Purefoy Hotel. In 1984, it was purchased by AIDB for use in a transitional living program for girls at the Alabama School for the Deaf.

LIDE HOME. This home on Seventeenth Street was built on a 520-acre plantation. It was the birthplace of Julia Lide, the only Alabama nurse to die in France during World War I.

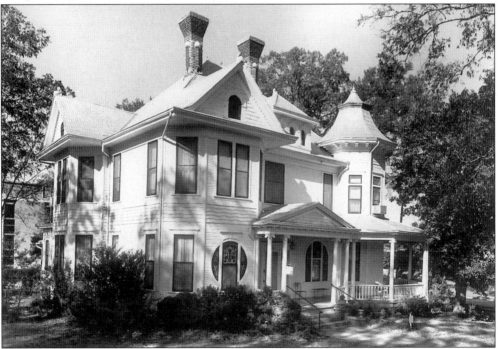

DR. E.B. WREN HOME. Designed by Frank Lockwood and built by R.S. West, the house was constructed between 1894 and 1903 on the corner of East and South Streets. The house plan incorporated interesting architectural features, including the "brick art" of the chimneys. Dr. Wren constructed a one-story building behind the home for his office. It still stands with the word "office" over the doorway.

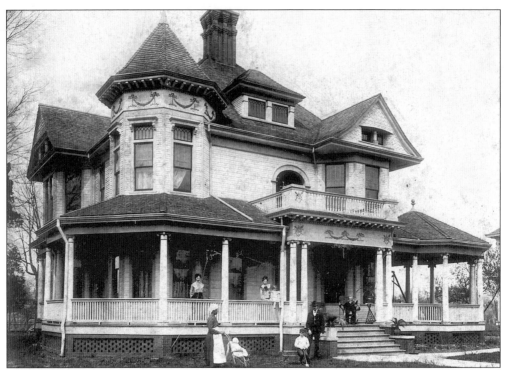

JONES-BOWDEN HOUSE. Located at 214 East South Street, the Leon Jones house was also built by R.S. West. A master craftsman, West taught carpentry and cabinet making at the Alabama School for the Deaf. The center chimney of the house had seven ducts drawing smoke from six fireplaces. The seventh duct dumped ashes into a basement pit. Pictured along with the family are Dr. H.G. Hendrick, one of Talladega's early doctors, and Mrs. J.W. Cowen. The home is now owned by the Jack Bowden family.

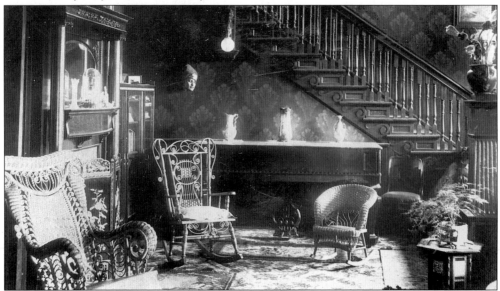

INTERIOR VIEW OF THE JONES HOUSE. Pictured is the parlor of the Jones home, which was one of the first houses in town wired for electricity.

FIRST HOME OF DR. E.H. JONES. Dr. Jones, an African-American physician, started practicing medicine from this home before the erection of his office building on West Battle Street. Shown with him is his close friend Lee de Forest, the "Father of Radio."

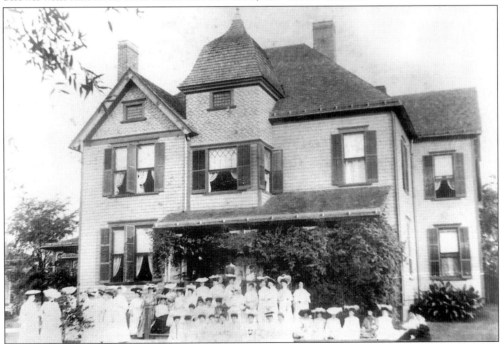

MCELDERRY, MALONE HOME. Ladies in white have gathered for a lawn party at the H.L. McElderry home at 303 East South Street. McElderry, a prominent local banker, married Ruth Van Ausdal of Eaton, Ohio, on January 5, 1887, and the house was built in 1905. The home was purchased in 1949 by Mr. and Mrs. W.C. Malone and remains in the Malone family.

Garden Wedding. Frequently couples were married in home weddings. The F.G. Stringer house was the scene of this garden wedding. Alex P. Stringer and Annie M. Conway were married March 14, 1901 by T.M. Callaway, pastor of the First Baptist Church. Allious Williams, a blind musician and long-time organist of the First United Methodist Church, provided the music.

President's Home. The home of the president of Talladega College was built in 1881 on the school's campus. President and Mrs. Henry Swift De Forest, along with son Lee, are shown on the porch of the home. The home is now occupied by Pres. Henry Ponder and his wife Eunice.

WHITWOOD. Pictured above is the family home of the Whitsons and Woods. The house was built in 1836 and consisted of two log cabins. George Knox Miller, the first white male child born in town, was reportedly born in one of the cabins. Shown in this pre-1905 picture are Uncle LaFayette Rogan, Grandmother Maria Wood, and the Wood daughters. After 1905, the house underwent major architectural changes. Local artist Sarah Whitson continues to reside here.

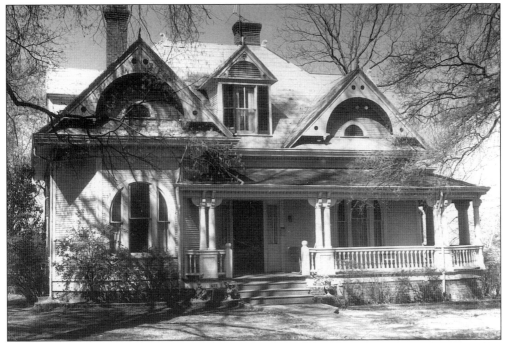

COWEN HOME. J.W. Cowen built this home for his first wife, Joanna Kingsberry Cowen, at 611 South East Street in 1890. At the time it was called "the loveliest new home in Talladega."

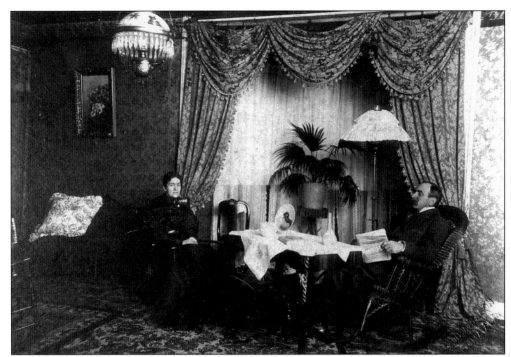

PARLOR OF F.C. McALPINE HOME. Frank C. McAlpine and wife Martha Clarke McAlpine are pictured in the parlor of their home at 505 South East Street. Following their wedding ceremony at the First Presbyterian Church in 1874, a large reception was held here at the home. The couple had six sons and two daughters.

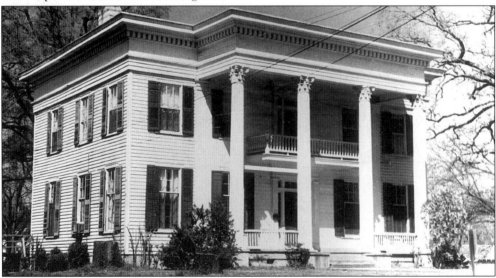

J.G.L. HUEY HOME. Built on East Street in 1840, the home was part of the Huey estate, which extended from the Southern Railroad to the old county club, west of East Street. The home was owned by the Huey family from 1840 to 1870, the William R. Stone family from 1870 to 1890, and the George W. Chambers family from 1890 to 1920. Situated next to Trinity United Methodist Church, it was acquired by the church and used as education space. It was razed in 1968, and a new wing of the church now occupies the site.

Four
MEMORY LANE

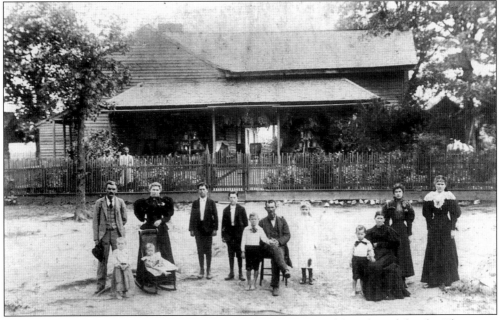

THE GIDDENS AND RAGAN FAMILIES. Many memories are of friends and family. These two families were photographed in 1895 in front of the Ragan home. On the left are Mr. and Mrs. William A. Giddens, son Fred, and baby Nena. The father owned and operated Giddens Coal Yard and later Giddens Supply. The Ragan family members, from left to right, are William D., John T., Robert L. Jr., Robert L. Sr., Helen, Cecil, Mrs. Robert L. Sr., Mollie, and Addie.

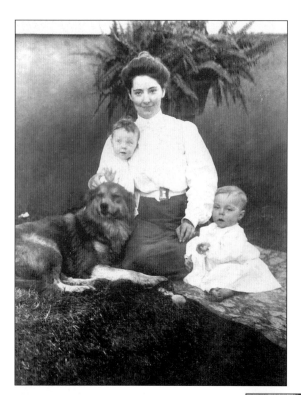

MRS. C.C. WHITSON AND SONS. Mrs. Whitson (Lulu), the daughter of Mr. and Mrs. J.P. Wood, is pictured with her twin sons, Joseph Carson and James Pinckney.

LERA JONES. Lera, born in 1876, moved to Talladega in 1881. Her father constructed a building on West Court Square, still often referred to as "the old Woolworth building." Here he opened a general store. A successful businessman, he became a director of the Talladega National Bank. On reaching adulthood, Lera married Joseph B. Graham, who became superintendent of both city and county schools.

McElderry Siblings. Pictured are some brothers and sisters in the Thomas McElderry family. John, seated at right, was a captain in the Confederate army and "fell in the battle at Varnell's Station, Georgia, May 19, 1864, in the 30th year of his age." George, standing at right, was the father of Mary McElderry, who married Art Decatur, a noted professional baseball player who once struck out Babe Ruth. Hugh (in center) was a successful lawyer, financier, and civic leader; he served six years as mayor of Talladega.

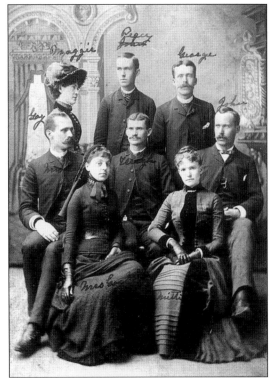

A Sunday Afternoon Ride. Were these couples about to enjoy a pleasant, leisurely ride? Or were they on their way to church—or to a wedding? Whatever the case, they were all dressed up and ready to go.

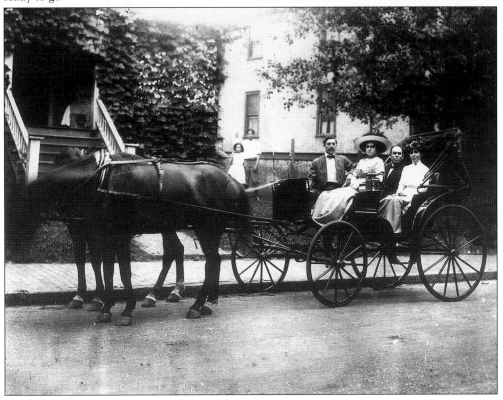

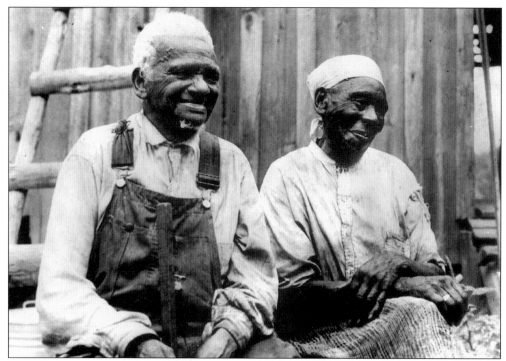

RELAXING AT HOME. This unidentified couple, relaxing in front of their home, seems to be enjoying life in the sunset years.

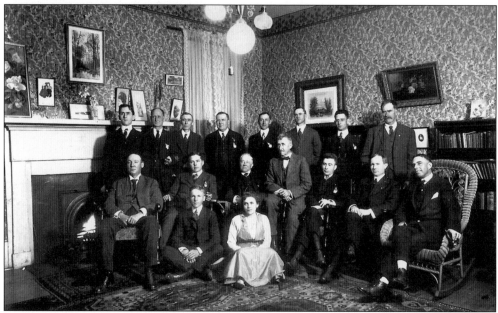

POSTAL WORKERS IN JEMISON HOME. Postal employees gathered in the home of Robert Mims Jemison, father of historian and author E. Grace Jemison. The house stood at 710 East North Street. Postmaster Jemison is in the center of the picture sitting on the armchair. In the 1990s, the historic house was dismantled and then reconstructed in Randolph County by Talladega coach and history teacher Phillip Sizemore.

MORETTI AND FRIENDS. Shown on the porch of the Cecil Browne home, this cheerful group was comprised of noted sculptor Guiseppe Moretti, Pearl Hammond, Ruth Chambers (Gay), Mr. Browne, and Nina Browne (O'Donavan.)

BLACKSMITH P.R. CRUMP. Crump (1847–1951), a Confederate veteran, is pictured practicing a vanishing occupation, that of blacksmith. Jack Blackmon, Talladega's last known blacksmith, closed his business in 1969.

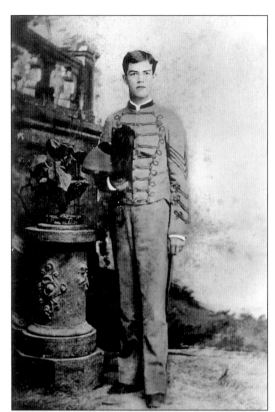

ROBERT HOUSTON MCMILLAN. The son of Robert Alexander and Missouri Isbell McMillan, Robert H. was born in 1867. Shown here in his cadet uniform, he graduated from Auburn in 1889. He and his brother James B. founded Talladega Cotton Mill in 1893.

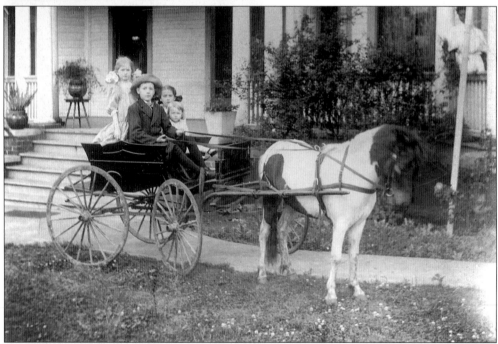

LEON G. JONES CHILDREN. Ready for a ride in their cart are the L.G. Jones children. From left to right are Margaret (Elliott), Turner, Mary (Ryley), and George.

THE C.S. WEAVER FAMILY. Three different centuries of Weaver family members contributed to Talladega. Pictured above in front of their Oak Street home in this 1909 photograph, from left to right, are the following: (front row, seated) Cabot, Dewey, Nina, Mother (Nancy Haynes Weaver), Alma, Papa (Charles S. Weaver), and Tenison; (back row) Kiser, Lora, Lassie, Ivera, and Jep.

SARAH HUSTON. Sarah (1884–1959), who later became Mrs. W.R. Brannon, is pictured at age 15, giving us some idea of what teenage girls wore at the turn of the century.

51

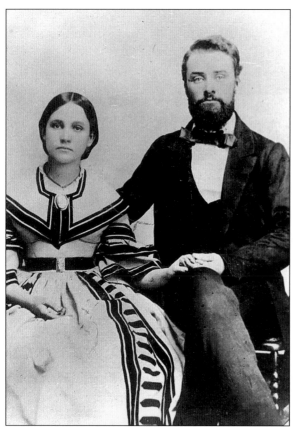

THE WEDDING TRIP. This couple, E.S. Jemison and bride Louisa McElderry, are shown on their wedding trip. "Aunt Lou," who was born April 20, 1842, married Jemison at age 15. The groom later served in the Confederate army. Following the war he became a successful railroad entrepreneur in Texas. Then, after living in New York briefly, the couple returned to Talladega. He died shortly thereafter. A philanthropist, she gave of her time, energy, and resources to improve life in the community.

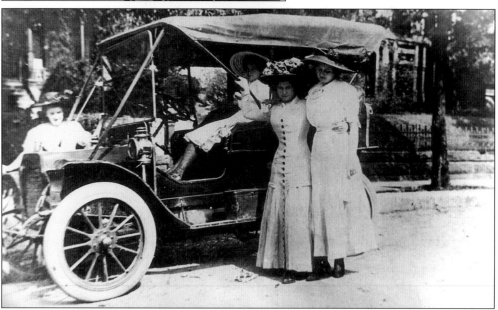

THE HORSELESS CARRIAGE. In 1914, the Cecil Browne family owned one of the few automobiles in town. The car was known as an "E.M.F." On the right is Nina Browne, who later married Lawrence O'Donavan.

Five
PATHWAYS OF FAITH AND AVENUES OF SERVICE

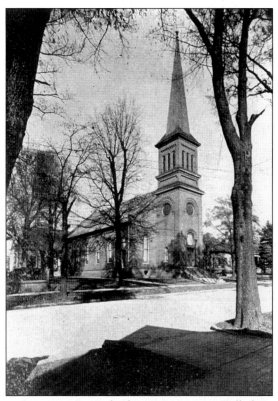

FIRST PRESBYTERIAN CHURCH. From the beginning, many Talladegans were people of faith. The First Presbyterian Church, which originally met in a rented log house, was organized November 28, 1834, before the incorporation of the town. The brick building pictured was begun in 1861, but the Civil War delayed its completion until October of 1868. Over the years, repairs and enlargements have been made, but the main sanctuary remains essentially the same.

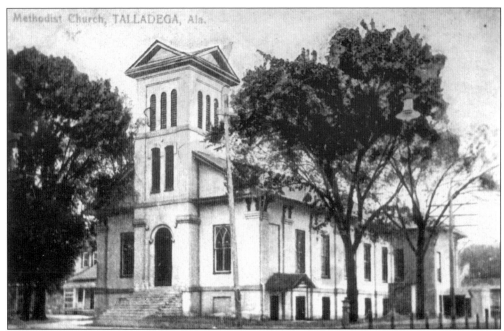

FIRST METHODIST EPISCOPAL CHURCH, SOUTH. Organized as a mission in 1833, the church (now First United Methodist) soon met in a frame structure where the present City Hall now stands. The building pictured was finished in 1857 and was located on the southeast corner of South and Court Streets. It was the first brick church erected in Talladega County. The Lance D. Grissett County Board of Education Building now stands here.

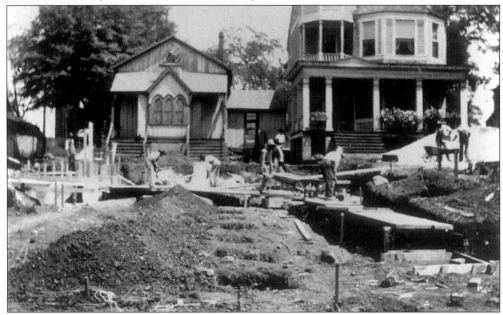

SAINT PETER'S EPISCOPAL CHURCH AND RECTORY. Saint Peter's was probably the first Episcopal Church in Alabama east of the Coosa River. The church pictured was razed following completion of the present structure, the foundation of which is shown in the foreground. The Reverend Harvey's family lived in the rectory until they left in 1936, and then it, too, was razed.

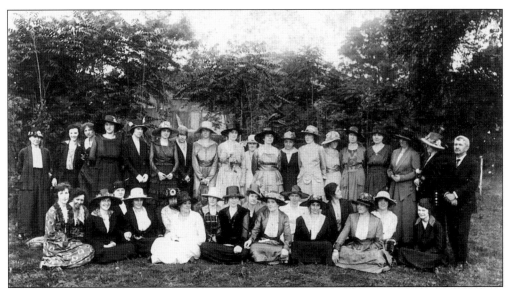

PHILATHEA SUNDAY SCHOOL CLASS. This ladies' class of First Baptist Church is pictured in 1915 with the teacher, W.B. Castleberry, shown at right. He was teacher of the class for many years and served as church clerk for more than 30 years. In the class were later leaders of the church, including Julia David (Mrs. J.S. Ganey), Lora Weaver (Mrs. G.W. Ragsdale), Earline McCain (Mrs. John I. Tubbs), Icye Luker (Mrs. H.R. Moore, Sr.), and Lassie Weaver (Mrs. W.C. Malone Jr.)

MOUNT CANAAN BAPTIST CHURCH. In 1870, more than 100 African Americans withdrew from Talladega First Baptist and formed the Mount Canaan Baptist Church. The original building was constructed on its present site but was destroyed by a storm in the spring of 1912. The church was rebuilt in 1913. The facade contains the bricks from the original 1870 building.

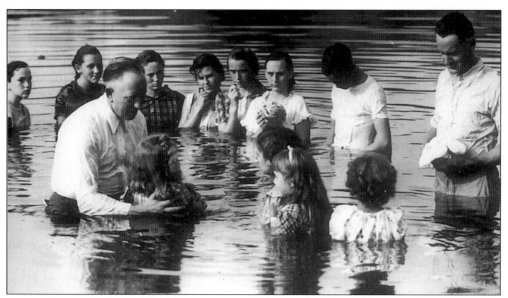

BAPTISM AT THE CREEK. This baptismal service took place in the early 1950s. Baptism in running water was common practice for many years, and baptism in a creek still occurs today. Some prefer to be baptized in "moving" water, "just like Jesus." Also, some churches do not have interior baptismal pools. (Photograph by R.E. "Buster" Hogan.)

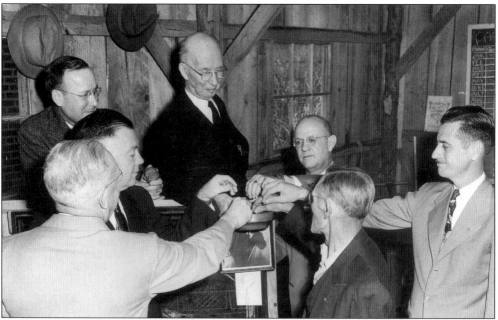

THE CROWE'S NEST. Dr. William Crowe, pastor of the First Presbyterian Church (1938–1959), was beloved in the community. He started the Caravan Sunday School Class for men in town not attending elsewhere. Named "The Crowe's Nest," the class indeed included men from different religious and ethnic backgrounds. Here members pay a "fine" for absences. To the left of Dr.Crowe (center), from left to right, are unidentified, John P. North, and George R. Burton. At the far right is Harold Tolleson. The other two are unidentified. (Photograph by R.E. "Buster" Hogan.)

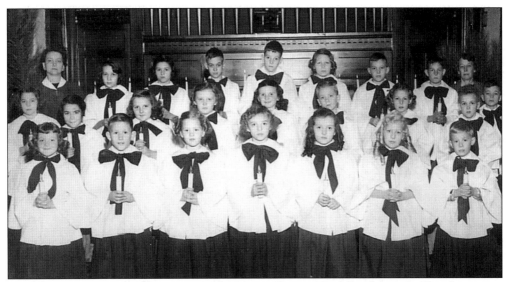

CHILDREN'S CHOIR AT CHRISTMAS. The Junior Choir of First Presbyterian Church sang on December 22, 1951. Members included Patti Thomson and Cleve Jacobs (first two from left on first row), who are now married. How many other children do you recognize? The director was Mrs. J.P. Creel (back row left), and the choir mother (back row right) was Mrs. Wallis Elliott. (Photograph by R.E. "Buster" Hogan.)

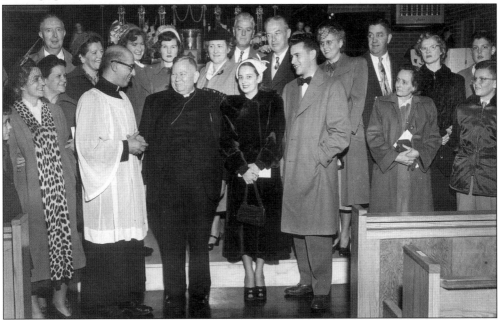

SAINT FRANCIS OF ASSISI CATHOLIC CHURCH. The first service in the completed building was in December of 1951. Bishop Thomas J. Toolen (center in black) dedicated the church. The first Mass, however, had been on Easter Sunday, 1950, with simply an altar, four walls, and folding chairs. The first priest to serve Saint Francis was Fr. Mac Paul Abraham (left in white vestment). Members pictured include Anna Cabana (second from left), Nancy Roberts (fifth female from left), and Martha Bruner (second from right). (Photograph by R.E. "Buster" Hogan.)

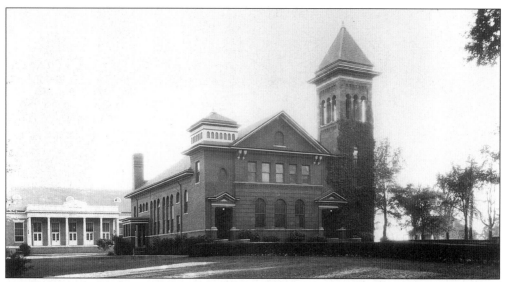

DeForest Chapel. Located on the campus of Talladega College, the chapel was built in 1905 in commemoration of the life and service of Henry Swift DeForest, beloved president of the school. The building was renovated in recent years, and beautiful new stained-glass windows were added. The chapel is used for religious services, general convocations, meetings, and concerts.

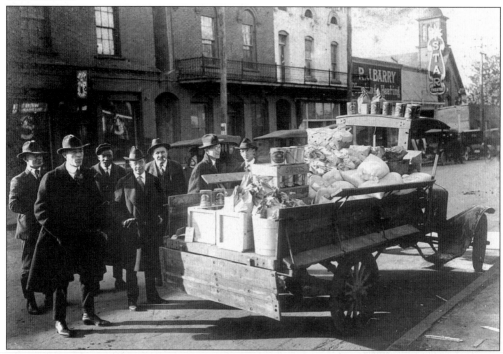

Elks' Charity Truck. Civic clubs and service organizations have added much to the well being of Talladega. During the Christmas season of 1919, food was loaded on this chain-driven Model T, the Elks' Charity Truck, and was sold to raise money for the poor. In the background is the west side of North East Street. The bell tower of the First Baptist Church can be seen at the top right.

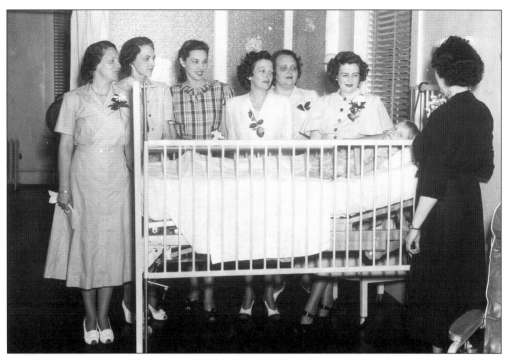

JUNIOR WELFARE LEAGUE. Service projects are the lifeblood of this organization. These 1930s members visit a child in the hospital. From left to right are Hope McMillan, Eleanor Johnson, Sarah Whitson, Sarah Hammett, Mrs. Aubrey Glass, and Mrs. Devan Dumas.

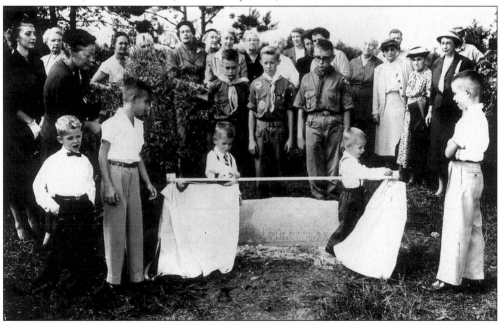

BOY SCOUTS AND DAR. In 1956, members of the Boy Scouts and the Andrew Jackson Chapter of the Daughters of the American Revolution dedicated a headstone at the grave of Judge Tarrant of Mardisville. The grave had previously been unmarked. Scouts in uniform are John Hyde, Wallis Elliott, and Pinckney Whitson.

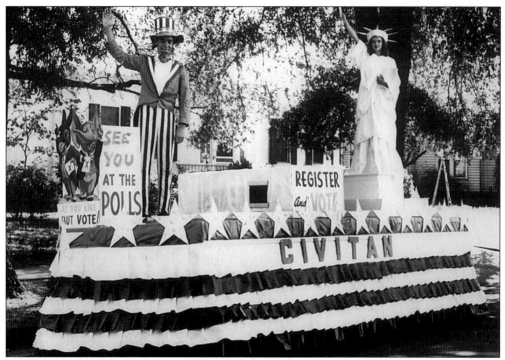

CIVITAN CLUB. The Talladega club has had numerous projects through the years, many related to aiding the mentally challenged, the youth of the city, and students at AIDB. Here the club sponsors a float encouraging citizens to vote.

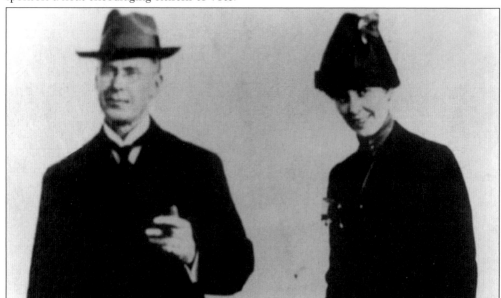

MAYOR AND MRS. WILLIAM H. SKAGGS. In 1885, at 23, Skaggs became the youngest mayor in the history of Talladega. He was also perhaps the most progressive, with numerous improvements and reforms being made. He later became a renowned lecturer and writer. He is pictured here with his second wife, the former Julia Frances Ollis of Kansas City, Missouri. Numerous leaders in government have rendered outstanding service through the years.

POLICE DEPARTMENT. Among the most valued public servants are the police. The 1905 force consisted of four men. Behind Chief W.J. Austin (seated), standing from left to right, are John Norred, Tobe White, and Ellie Watts.

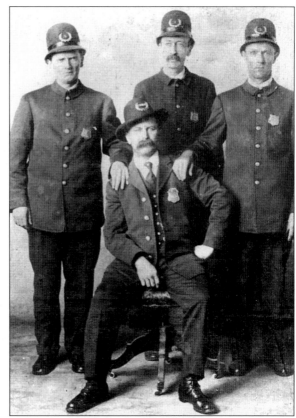

FIREMEN'S TOURNAMENT. On May 25, 1909, Talladega was host to the Georgia-Alabama Volunteer Firemen's Association competition. A fire was started on Court Street. When the alarm sounded, firemen slid down a pole from the second floor of the firehouse, hitched their horses, and raced to the fire. Contests were held to determine which team had the swiftest horses and the quickest work in extinguishing the fire. This picture is of the east side of the square, which included Northern's Drug Store.

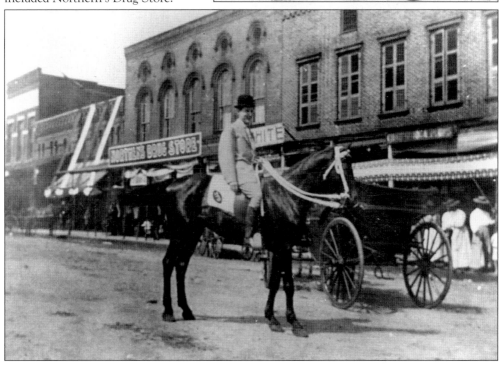

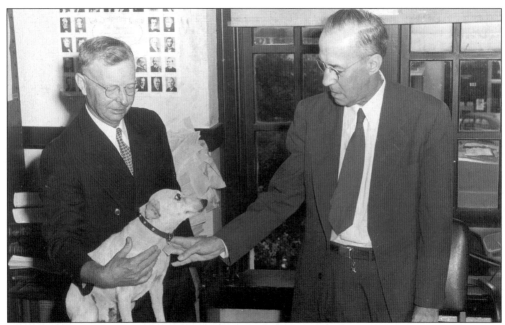

PUBLIC SERVANTS. Attorney Earl Montgomery is shown with his dog Bob and Register in Chancery M.R. Joiner, a former mayor. Montgomery probably tried more cases than anyone else in Talladega in the 1920s. His little dog Bob was known to many Talladegans in the 1940s and 1950s, for he followed Montgomery everywhere—including the courtroom, where he would lie at his master's feet while the well-known lawyer would plead the case. (Photograph by R.E. "Buster" Hogan.)

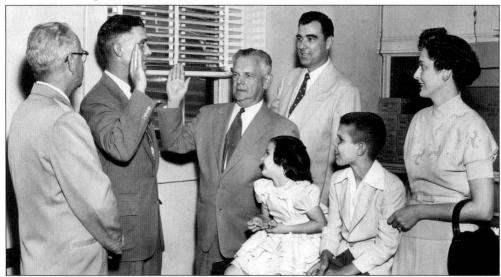

DR. HARDWICK IS SWORN IN. Dr. James L. Hardwick, beloved Talladega physician, is sworn in as mayor of the town as outgoing Mayor Wallis Elliott administers the oath (October l, 1953.) Looking on are his children Kathy and Craig and wife Dorothy (Dot). J.B. Marlow, Hardwick's pastor at First Baptist Church, stands behind Elliott. Hardwick served as mayor until 1971, doing much for Talladega in this and other capacities. One lasting contribution was his role in bringing the speedway to Talladega. (Photograph by R.E. "Buster" Hogan.)

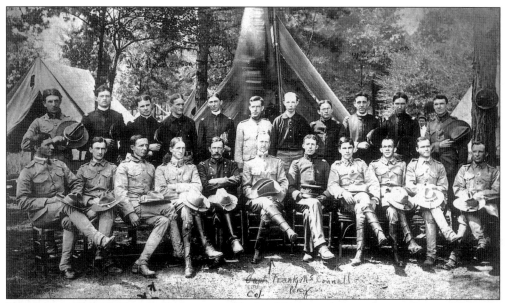

TALLADEGA RIFLES. Some of our most valued public servants are those who served in the armed forces. The Talladega Rifles were first organized during the Civil War. This picture was made around 1898 when war was declared with Spain and many members volunteered. Among the members were Jim Henderson, W.Z. Jackson, Dr. Lawson Thornton, and Frank Percy McConnell.

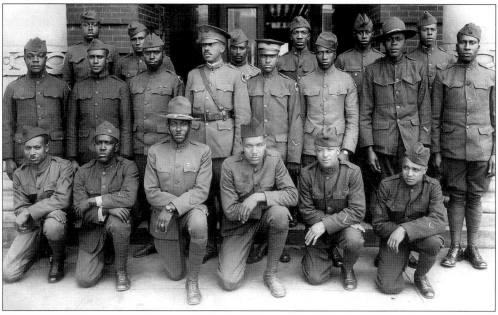

SOLDIERS IN WORLD WAR I. Posing in front of the courthouse, these men prepare to leave for service in the world war. Although African Americans were among those who thronged the recruiting stations in April 1917, most were not received. After passage of the Selective Service Act, however, more than 700,000 registered. Eventually 367,000 African Americans were called into service. These men and women served valiantly. Following the war, they hoped to be rewarded with increased civil rights, but the rewards were not immediately forthcoming.

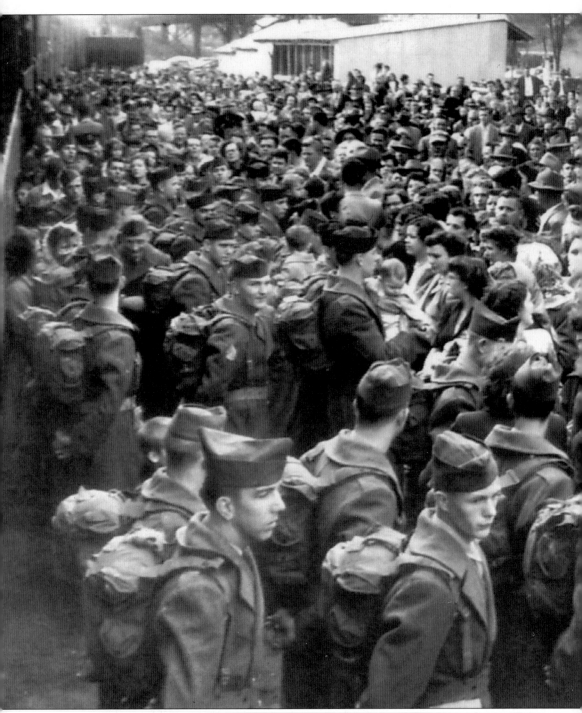

OFF TO KOREA. Local men leave for National Guard training, expecting to wind up in Korea. Mrs. Irene Nabors, trying to hold back the tears, presses a handkerchief to her lips while her husband Jack (with hat) stands at her left. Their son Robert Earl ("Bunky") is in the departing group. Harry Walker Sherman is immediately behind the lady at Mrs. Nabors' right. Can you find others, including "Cat" Hart and Virgil Rutledge? The scene is on the north side

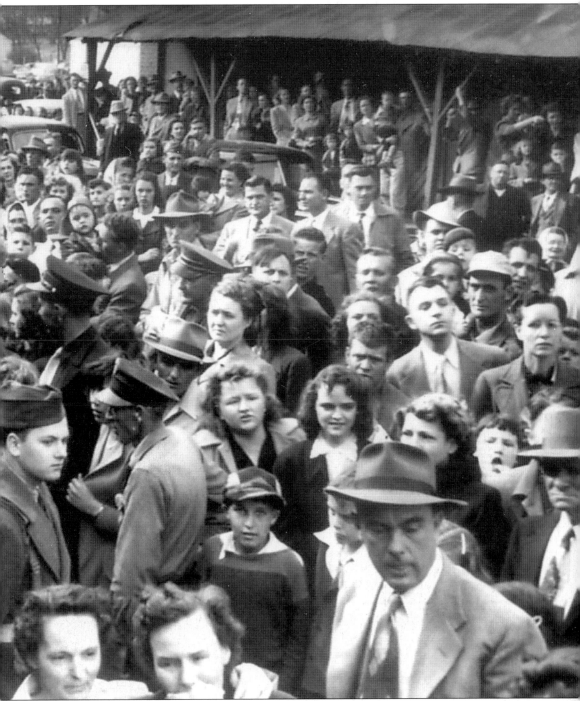

of the Southern railroad tracks at East Street. The Old Oil Mill building is at right; the train is at left. Before this departure scene, some Talladegans were already in Korea. Hubbert Hubbard was part of the first amphibious troops to land in Korea (July 5, 1950.) (Photograph by R.E. "Buster" Hogan.)

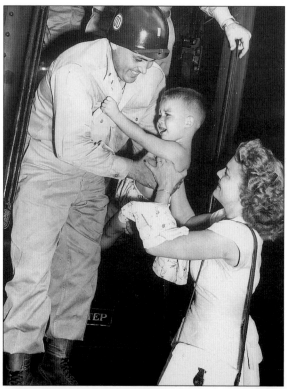

A Child's Plea. In the photo at left, little Donald cries and grasps for the jacket that belonged to his father Preston "Piggy" Brown. Mrs. Bert Brown tried to show courage as she comforted their son while waiting for Mr. Brown to depart for the conflict in Korea. (Photograph by R.E. "Buster" Hogan.)

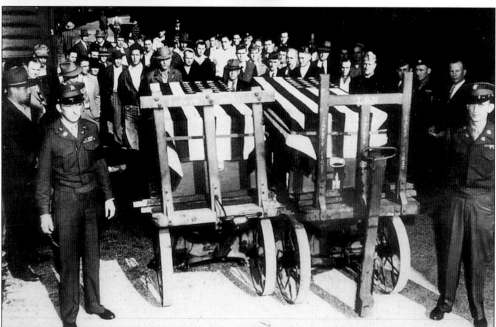

The Ultimate Sacrifice. The first two Talladegans who gave their lives in the Korean Conflict were brought back into town by train. A large assembly gathered to mourn and to pay tribute. These soldiers represent all those in all wars who gave their lives in the service of their country. (Photograph by R.E. "Buster" Hogan.)

Six
PUBLIC ROADS AND PUBLIC BUILDINGS

THE HISTORIC COURTHOUSE. Although major modifications have been made over the years, the Talladega County Courthouse remains the oldest courthouse in continuous use in Alabama, having been completed in 1838. This photograph was taken between 1911 and 1925 when there were columns on all four sides of the building. Evidently, cotton was still big business in that era!

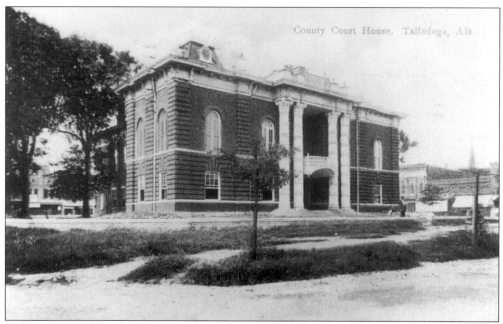

SOUTH ANNEX TO COURTHOUSE. In April 1905, R.S. West contracted to build the south annex. The clock tower of the old part of the courthouse remained visible above the roof line. From 1910 to 1911, a north annex was constructed, and at the same time columns were placed on the east and west sides of the building.

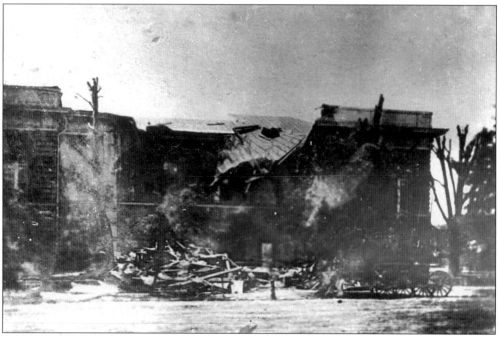

TORNADO, MAY 11, 1912. The storm blew down the clock tower of the courthouse. In its fall, the clock crashed through the roof of the east piazza, bringing down the heavy stone pillars. Other buildings, including the firehouse and the Mount Canaan Baptist Church, were also severely damaged.

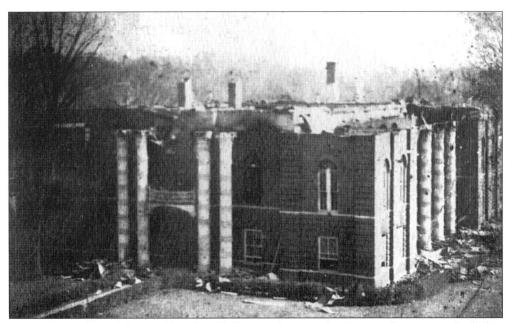

COURTHOUSE FIRE, MARCH 13, 1925. Following the tornado, the courthouse was rebuilt, but 13 years later, on Friday the 13th, the building burned. When the fire was discovered, former employee Knox Camp broke a window, climbed inside, and locked the record books safely in the vault.

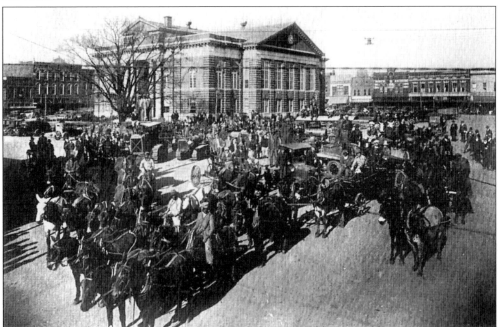

COURTHOUSE AFTER REBUILDING. Following the fire, Chattanooga architect R.H. Hunt was hired to redesign the building. When it was rebuilt, the east and west entrances were enclosed, providing more room. A Seth Thomas Clock was purchased for $1,597.50 and was installed at a cost of $63 by Talladega locals R. Heine and E.R. Jacobs. Pieces of the columns from the closed entrances were sold, and today they can be seen on lawns and in gardens around town.

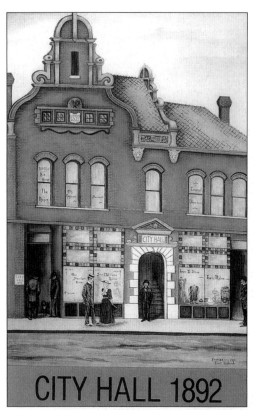

CITY HALL 1892

FIRST CITY HALL. The first city hall was built in 1892 on the south side of West Battle Street. Preliminary plans were made during the W.H. Skaggs administration, though actual construction took place while E.H. Dryer was mayor. City offices were located on the second floor, and the first floor was rented space. The building is of Flemish architecture. (Research and painting by Frances Sweat Upchurch.)

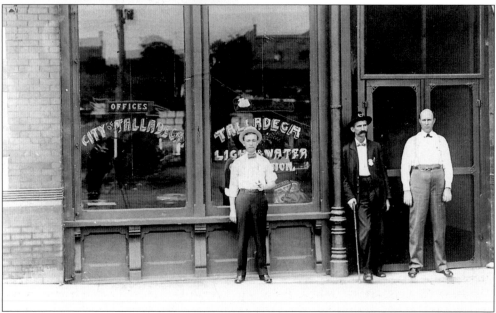

OFFICES FOR CITY OF TALLADEGA. Standing in front of the "City Building" in 1907 are W.L. Coker, city clerk and tax collector; Z.W. Grogan, chief of police; and Daniel A. McNeill, principal of the high school. McNeill later became superintendent of the county schools and ended his career as superintendent of the Alabama Institute for Deaf and Blind.

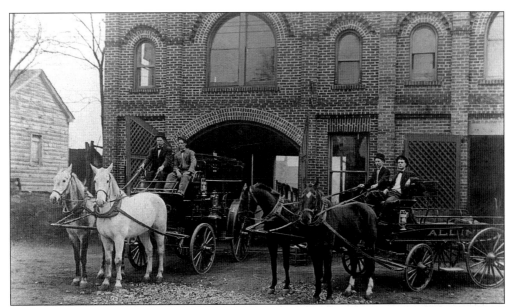

FIRST FIREHOUSE. This two-story firehouse was built in 1901 at a cost of $750 by local contractor Z.H. Clardy. The building faced West North Street near the Spring Street corner. The firemen from left to right are S.O. Wesley, J.O. Ray, Moton Lige, and an unidentified man.

DONAHOO BUILDING-POST OFFICE. Before the federal post office was constructed, postal services were usually rendered at the postmaster's place of business. From 1893 to 1897, postmaster John H. Donahoo Jr. used his building on the northeast corner of court square as the post office. The curved sign on the sidewalk in front identifies the "post office." From left to right are A. Hall, Donahoo, A.G. Storey, Bert Henderson, R. Mims Jemison, ? Porter, and ? Griffin.

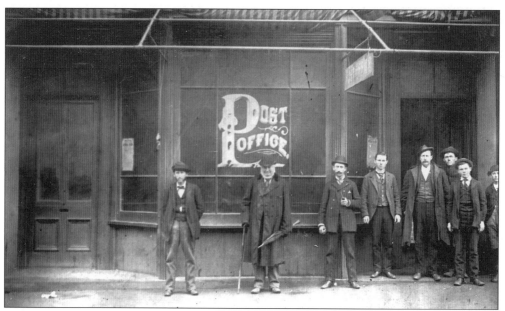

POST OFFICE, 1898. Around the turn of the century, J.A. Bingham was postmaster, and the post office was in his building on the east side of East Street North, back of the old Belk-Hudson Building (now Sneakers and the Coleman Ballroom). Pictured from left to right are R. Mims Jemison, A. Hall, A.G. Storey, H.C. ("Bert") Henderson, John H. Donahoo Jr., unidentified, George Porter Sr., and J. Sparks.

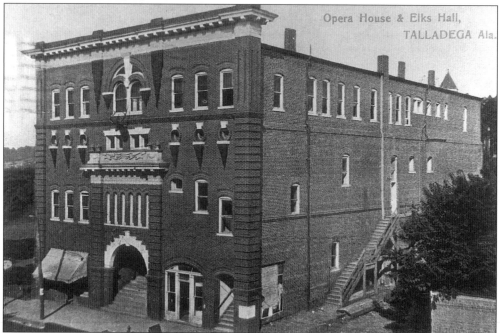

ELKS' HALL AND THEATER. The Elks' Theater, located on the east side of East Street North about one-half block from the square, opened October 3, 1905, with A.G. Fields' minstrels performing. At a total cost of $40,000, the building housed eight dressing rooms, a 17 x 60-foot stage, and an auditorium with a seating capacity of 1,000. The theater burned in 1928.

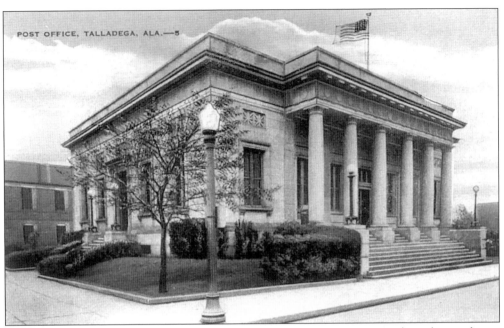

FIRST FEDERAL POST OFFICE. The first federal post office was constructed on the northwest corner of the square in 1912. This building, constructed by Fred West, was located on the site of the old Exchange Hotel. J.A. Bingham sold the property to the government in 1908 for $17,000. He was postmaster during the erection of the building and was the first postmaster to conduct business at the location. The building is currently occupied by the Talladega Water and Sewer Board.

CITIZENS HOSPITAL. In 1925, the Alabama Synodical College building was purchased by Talladega citizens who improved and expanded the structure, turning it into a hospital in 1943. The Governor Parsons home east of the hospital was used as a residence for nurses in training. In 1970, the old building was razed and a new hospital was erected.

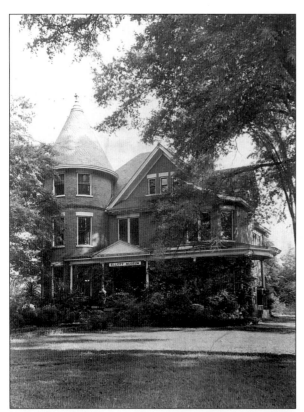

ELLIOTT MUSEUM. Mrs. Ida Wallis Elliott purchased this house built by Dr. Joe Johnson and his sister Annie and opened it as a museum. As head of a large travel agency, she collected interesting items from across the world and displayed them in the museum. Unfortunately, World War II forced its closing, and the building later burned. The City Board of Education building now occupies the site.

WREN MEMORIAL. Built on Sloan and North East Streets by Dr. E.B. Wren and other Talladega citizens, the structure was a memorial to Capt. E.R. Wren, a World War I hero. For years, it served as headquarters of the American Legion. Today it is used as a ballroom, meeting center, and antique shop.

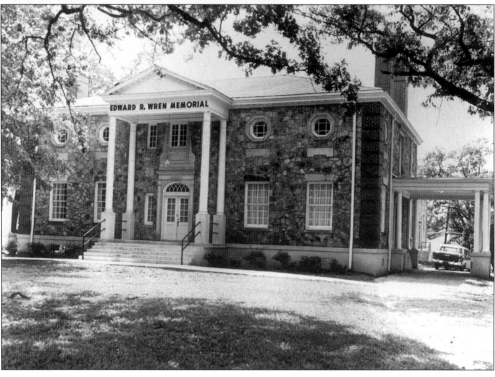

Seven

EDUCATION WAY AND INSTITUTION ROW

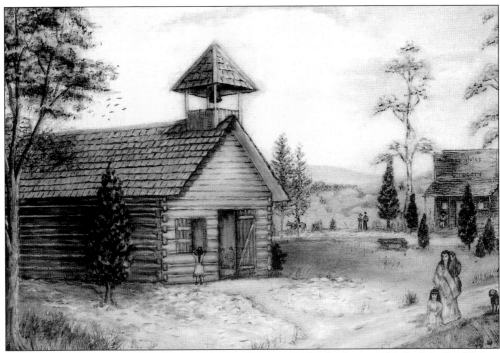

FIRST SCHOOLHOUSE. Talladega's first schoolhouse was built about 1833, before the Native Americans were removed from the area. The school faced Spring Street South just behind the Big Spring. The first teacher, Susan S. Spear, allowed her students to share lunches with the Native Americans. She had a day school for the neighborhood and a "select school for young ladies." (Research and painting by Frances Sweat Upchurch.)

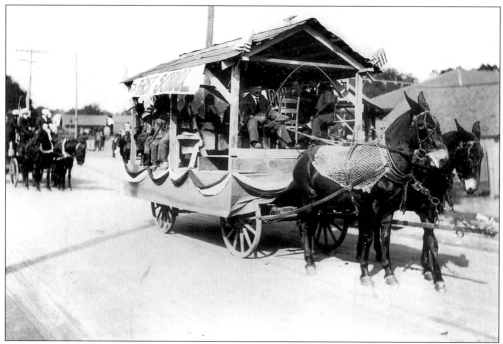

SCHOOLHOUSE FLOAT. The float was part of the 1913 Centennial Celebration of the Battle of Talladega. Representing the first schoolhouse, it demonstrated the importance some of the early settlers placed on education. The driver was school administrator D.A. McNeill. Native American and white pupils were portrayed by Gladys Corbett, Jep Weaver, Elizabeth Simms, Minnie J. Wright, Mangus Argo, Joe Graham, Irene Heacock, Mabel Hubbard, and Harry Berkstresser.

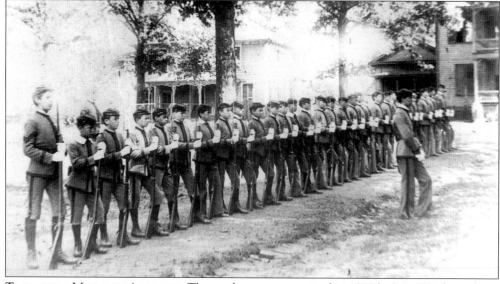

TALLADEGA MILITARY ACADEMY. The academy was organized in 1893 by J.A. Wright and was located on the Lyman property on North Street where the First Baptist Church now stands. Officers were Capt. Clarke McAlpine (left) and Lt. Claude Plowman. Many young men from the Talladega area were prepared for college at this school.

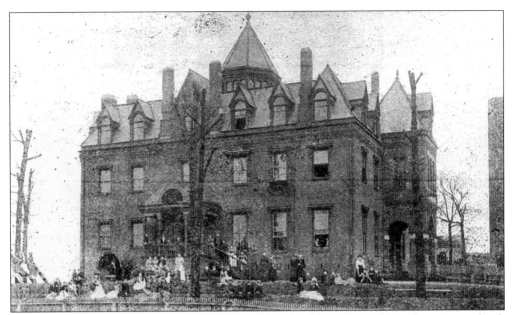

ALABAMA SYNODICAL COLLEGE FOR WOMEN. The school began in 1850, and a two-story brick building was constructed in 1851. This 1905 photograph shows the west side of the building after renovation and enlargement some years earlier (1891). The school was located on the crest of the hill behind First Presbyterian Church. The 1905 president was Rev. Peyton Walton, whose wife taught piano. Other courses offered were mathematics, Latin, English, French, organ, harmony, theory of music, drawing, painting, voice, chorus singing, and culture.

1908 GRADUATING CLASS. These young ladies graduated from Alabama Synodical College in 1908. Dr. Walton, principal, is seated between the Heacock twins, Irene and Kathleen. "Miss Nellie," who for years operated a popular boarding house, is on the left of the peak formed by the young women.

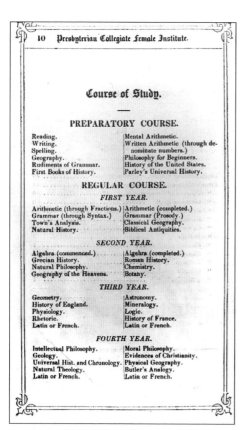

Course of Study.

PREPARATORY COURSE.

Reading.	Mental Arithmetic.
Writing.	Written Arithmetic (through denominate numbers.)
Spelling.	
Geography.	Philosophy for Beginners.
Rudiments of Grammar.	History of the United States.
First Books of History.	Parley's Universal History.

REGULAR COURSE.

FIRST YEAR.

Arithmetic (through Fractions.)	Arithmetic (completed.)
Grammar (through Syntax.)	Grammar (Prosody.)
Town's Analysis.	Classical Geography.
Natural History.	Biblical Antiquities.

SECOND YEAR.

Algebra (commenced.)	Algebra (completed.)
Grecian History.	Roman History.
Natural Philosophy.	Chemistry.
Geography of the Heavens.	Botany.

THIRD YEAR.

Geometry.	Astronomy.
History of England.	Mineralogy.
Physiology.	Logic.
Rhetoric.	History of France.
Latin or French.	Latin or French.

FOURTH YEAR.

Intellectual Philosophy.	Moral Philosophy.
Geology.	Evidences of Christianity.
Universal Hist. and Chronology.	Physical Geography.
Natural Theology.	Butler's Analogy.
Latin or French.	Latin or French.

COURSE OF STUDY. The synodical college, which underwent several name changes through the years, began as the Presbyterian Collegiate Female Institute in 1850. Courses offered in 1851 included such interesting subjects as town's analysis, Grecian History, geography of the heavens, rhetoric, and natural theology. Lewis E. Parsons, later provisional governor of Alabama (1865), served on the board of directors at this time, as did lawyer Alexander White, banker James Isbell, and other notables.

CASSIDY SCHOOL. The Cassidy School was built in 1883 on the campus of Talladega College. It served as a school for African-American children and as a place for the college students to do their practice teaching. Photographed here around the turn of the century, the building unfortunately burned in 1932. (Courtesy of Talladega College.)

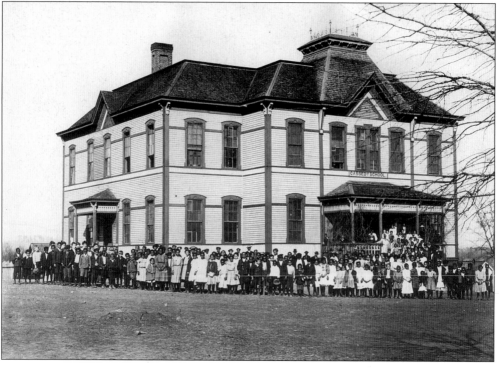

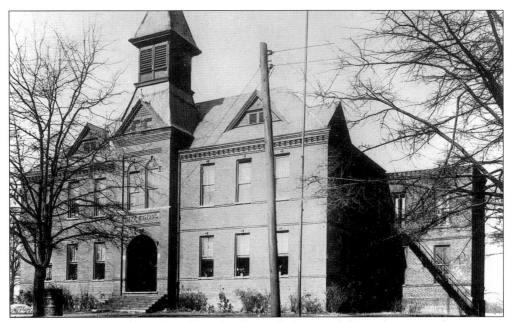

NORTHSIDE SCHOOL. The only public school in Talladega until the 20th century, the structure was erected in 1886, the cornerstone being laid by the Masonic Lodge on November 3. The proposal to issue bonds to pay for the $16,000 building was perhaps "met with more controversy and opposition by citizens than any other movement ever launched in the town." Under the leadership of Mayor Skaggs, however, the method was approved. Razed in the 1960s, it was replaced by a new structure now named Northside-Hal Henderson Elementary School.

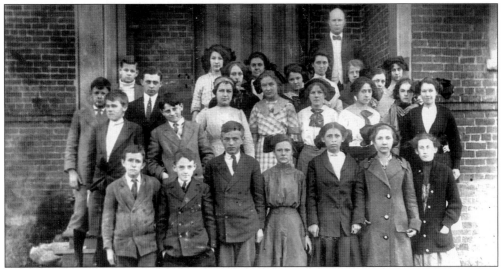

EIGHTH GRADE CLASS. In 1911, the eighth-grade class at Northside was pictured with the superintendent, D.A. McNeill. From left to right are the following: (first row) Robert Jemison, Howard Camp, Trotter Jones, Evie Respess, Lucy Rogers, Mary Stringer, and Laura Watts; (second row) Tom Parsons, Brewer Dixon, Ethel Fulmer, Ethel Rogers, Eloise McCain, Minnie J. Wright, Mayme Morriss; (third row) T. Burton, Hal Graves, Louise Jacob, Rita Shouse, Bessie Morriss, Virginia Rogers. Fourth Row: Arnold Simms, Jewell White, Ferne Austin, Annie Laura Stringer, Frances Jemison, and Catherine Venable.

GRAHAM SCHOOL. The school was built in 1904 and was named for Joseph B. Graham, former superintendent of education who had been killed the previous year in a freak train accident. Known statewide, Graham had served as president of both the Alabama Education Association and the Alabama County Superintendents Association. A new adjacent Graham building was erected in th 1930s, but the original structure is still in use.

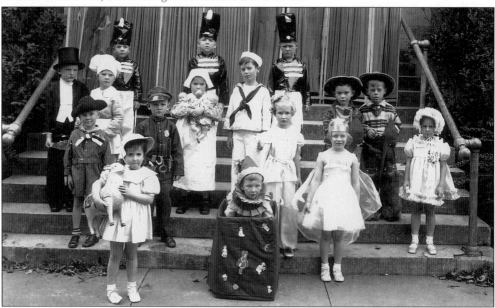

JACK-IN-THE-BOX AND COMPANY. Mrs. S.G. Plummer's 1935 kindergarten class is shown on the front steps of the old First Methodist Church building. From left to right are the following: (first row) Betty McFarlane, Charlie Miller, and Emelyn McLane; (second row) Walter Grider, John Hicks, Betty Elliott, and Mary Ellen Rozelle; (third row) Bobby Gene McBride, Ercell Howell, Elsie Ann Screws, Bailey Dixon, Dick Burton, Edgar Vaughn; (fourth row) Marvin Skeen, Billy Copeland, and Benton Cogburn.

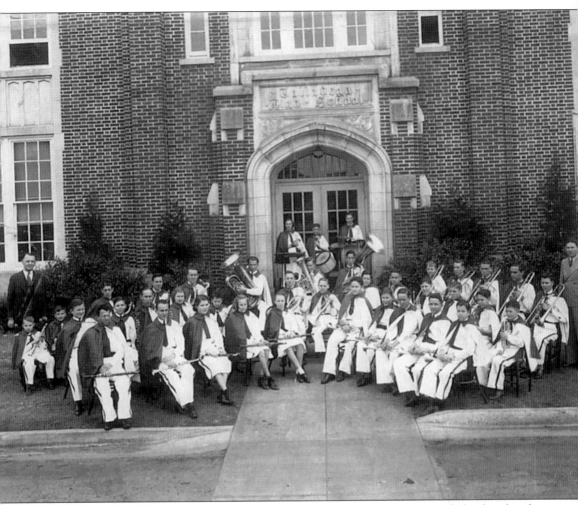

Talladega High School Band. Around 1935, Carlton Merck organized the first band. Actually, some members had already graduated, some were from out of town, and at least one was just a first grader. Parents made the uniforms; the girls were not allowed to wear pants—only skirts. Practice for the whole group was not done at school, but at night in various homes and businesses. It was not a marching band, but members did perform at some important events, including statewide meetings of AEA. This picture, made in the front doorway of the school, was taken in 1936. From left to right are the following: (front row) Dewitt Hanks, Alton Tinney, Pauline Swindall, Gladys Tinney, Elizabeth Jackson, W.W. Hall, Marion Albright, J.N. Robinson, Jimmy Todd, and Hardy Conner; (second row) Cecil Monroe, Walter Heacock, A.O. Yoe, Polly Cox, S.A. Behr, Claude Erwin, Harold Erwin, Norman Behr, unidentified, Charles Tised, Jack Burns, Leonard Held, and Jack Bishop; (third row) Pat Tinney, Paul Swindall, Pat Lanier, William Malone, Charlie Snead, Jimmy Naff, Walter Baker, Charlie Brown, Carey Erwin, Howard McLemore, Fred Lewis, Meredith Yoe, and Howard Conner. Also pictured standing in the doorway from left to right are Irene Tinney, Billy Franks, and Sarah Naff. Director Merck stands to the left while latecomer "Snooks" Cowart is pictured on the right.

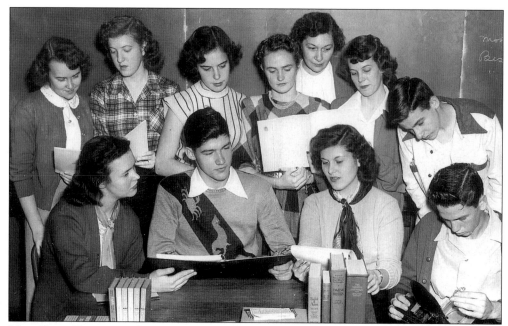

MISS ZORA ELLIS AND STUDENTS. Miss Ellis (right, rear) taught English at Talladega High School from 1926 to 1968. During most of those years, she was also sponsor of the school yearbook. She endeared herself to her students, teaching lessons in living as well as subject matter. She served as president of the AEA and both state and national Delta Kappa Gamma organizations. The building she taught in for so long is now named for her—Zora Ellis Junior High School.

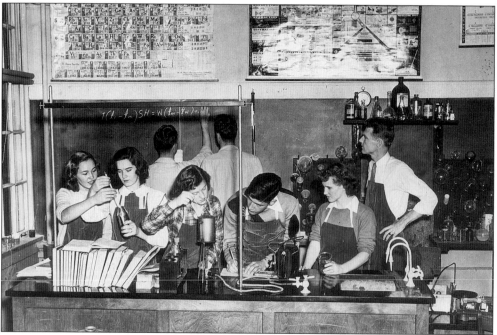

THS SCIENCE CLASS. School can be fun! These 1950s Talladega High School students seem to be very involved in a hands-on chemistry experiment.

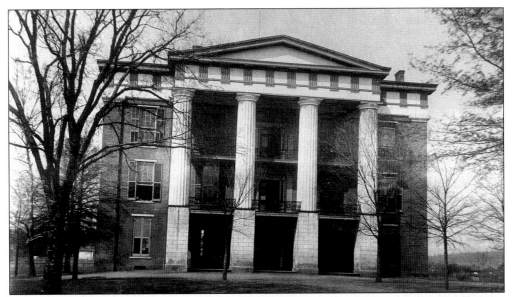

TALLADEGA BAPTIST MALE HIGH SCHOOL, SWAYNE HALL. The Baptist high school building was completed in 1854 with the use of slave labor. The school was forced to close during the Civil War, when the building was used as a prison for Union soldiers. In 1867, the structure became the first building of Talladega College and was named for General Wager Swayne, head of the Freedmen's Bureau in Alabama. (Courtesy of Talladega College.)

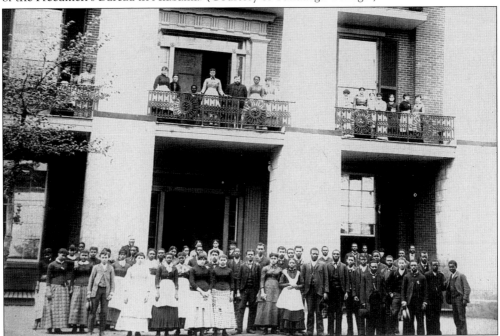

TALLADEGA COLLEGE. The institution is Alabama's oldest historically African-American, private four-year liberal arts college. The school was founded in 1867 by freedmen William Savery and Thomas Tarrant, who were assisted by Gen. Wager Swayne and the American Missionary Association. Students are pictured outside Swayne Hall, a National Historic Landmark. It is currently undergoing significant restoration. (Courtesy of Talladega College.)

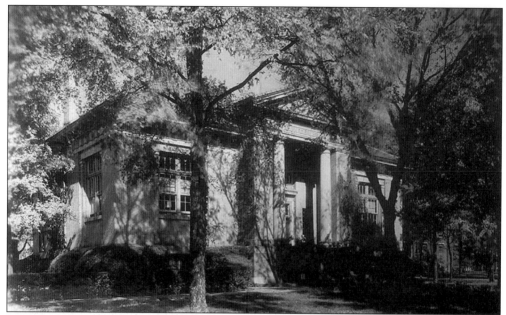

SUMNER HALL. A beautiful structure on the campus of Talladega College, the building was erected in 1904 as a library, the gift of Andrew Carnegie. It eventually was named for Frederick A. Sumner, president of the institution from 1916 to 1933. The building was remodeled in 1939 and became the administration building. Following a disastrous fire, a "new Sumner" was erected on the spot in 1965. (Courtesy of Talladega College.)

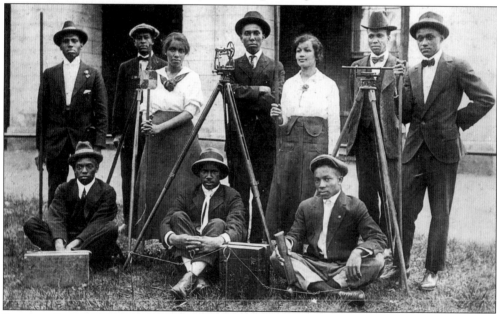

SCIENCE CLASS AT TALLADEGA COLLEGE. This group of late 19th century science students is studying surveying. Numerous graduates in science today pursue advanced degrees, many of them becoming medical doctors. Peterson's Guide *Top Colleges for Science* ranked the school as one of 200 colleges and universities in the nation that offers "an outstanding undergraduate program in science and mathematics." (Courtesy of Talladega College.)

GRADUATES OF 1893. These attractive, finely dressed young ladies were graduates in the "normal department," or teacher training division, of Talladega College in 1893. At the bottom left is Josephine Savery Herring, daughter of William Savery, one of the founders of the college. The library, which contains world famous murals of the *Amistad*, is named for Savery. (Courtesy of Talladega College.)

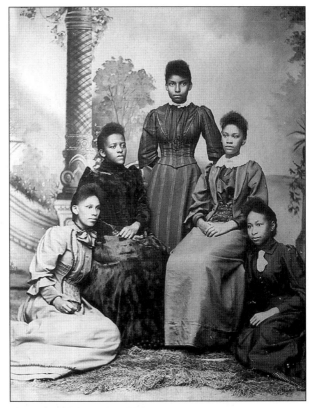

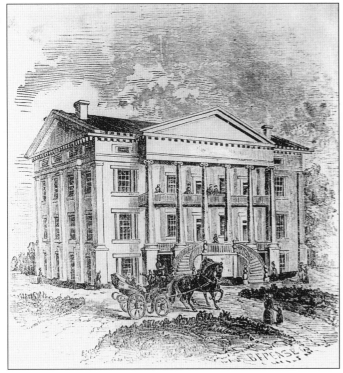

MANNING HALL OF AIDB. Now the administration building and museum of Alabama Institute for Deaf and Blind, this impressive edifice was constructed by the Masons of Alabama in 1851 as East Alabama Masonic Female Institute, a school for daughters of indigent parents. In 1858, it became the original building of AIDB, now one of the leading institutions in the world for the sensory impaired. The drawing was done by a student at ASD in the late 19th century.

85

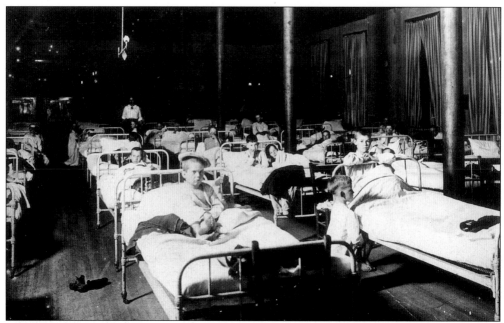

DORMITORY ROOM—ASD. Young boys prepare for bed in their dormitory room in old Taylor Hall, named for longtime board member Dr. William Taylor (1860–1908). Faculty and staff members served as surrogate parents for the youngsters. This building, with its massive columns, had a beautiful exterior; but in the 1950s, the cost for renovation was seen as being prohibitive, and the building was demolished and replaced with a modern structure.

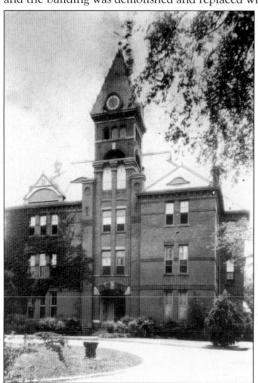

ALABAMA SCHOOL FOR THE BLIND. Although there had been a special class for the blind at the institute since 1867, a law providing for a separate state school for the blind was not passed until February 19, 1887. The school was located on South Street, and Dr. J.H. Johnson, Jr., was named the first superintendent in 1888. This building, like many other beautiful buildings in Talladega, was eventually destroyed for "modernization."

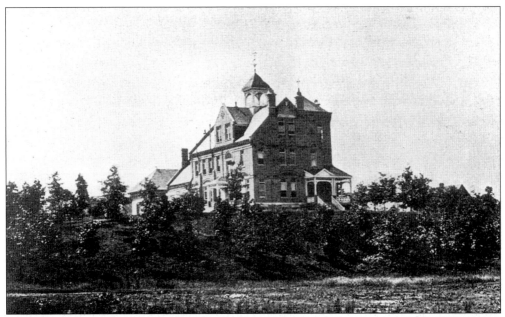

SCHOOL FOR NEGRO DEAF AND BLIND. The school opened on January 4, 1892, with Dr. Josiah S. Graves as its first superintendent. Six of the city's most prominent African-American citizens, led by the Rev. J.P. Barton, were enlisted to monitor the interests of the black students in the school. The building was located on East McMillan Street. Students at the institute were integrated in the 1960s.

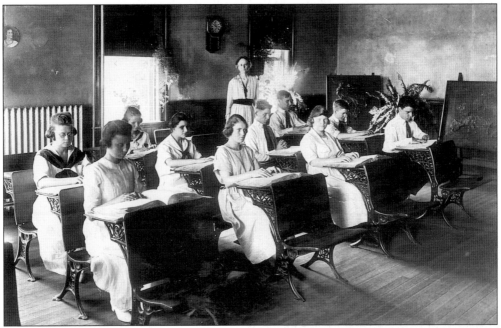

CLASSROOM AT ASB. This classroom was in old Asbury Hall, named for Reuben Rogers Asbury, whose dream had led to the creation of a department for the blind in 1867. In the photograph, Annie Brockman teaches a class reading Braille. She and her sister Ida served ASB for many years, and a building on campus was named for them.

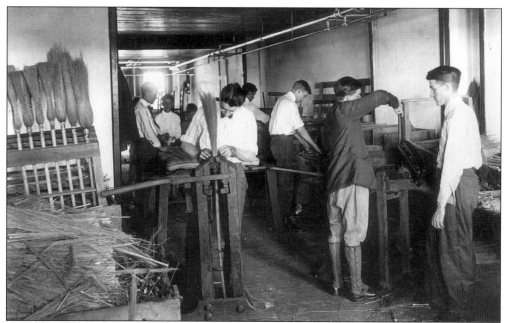

BROOM SHOP AT ASB. Students are busy at work in the broom shop of Alabama School for the Blind. Broom making began at the school with its founding in 1867, and it continues to this day at the Industries for the Blind. Young women at ASB learned to weave willow baskets, use sewing machines, and operate looms. Upper level academic courses also came to be emphasized.

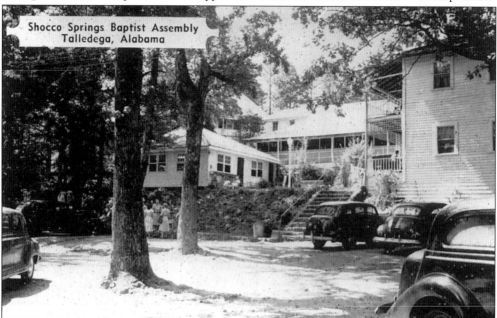

SHOCCO SPRINGS BAPTIST ASSEMBLY. Alabama Baptists purchased Shocco Springs, then known as a "rowdy resort," in December of 1947 at a cost of $62,500. At first a summer assembly, Shocco is now a year-round conference center bringing thousands to Talladega every year. The campus has been enlarged, new buildings have been constructed, and youth camps have been added.

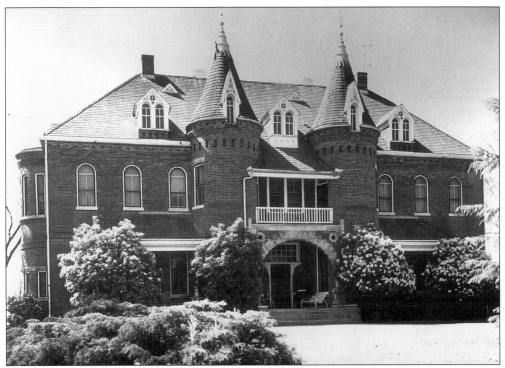

PRESBYTERIAN HOME FOR CHILDREN. The "orphanage" was moved from Tuskeegee to Talladega in 1891. This beautiful structure was the first building of the Presbyterian Home in Talladega. First used to house both staff and children, it later became the administration building and was named Bellingrath Hall. Eventually it was razed and replaced with a more modern, utilitarian building.

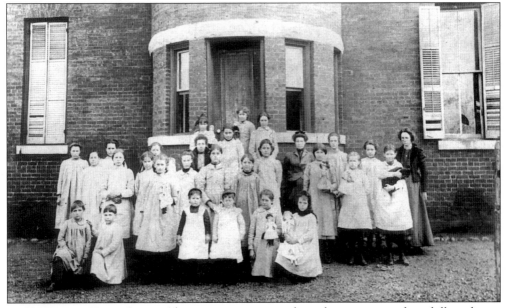

PRESBYTERIAN HOME GIRLS. About to enjoy a party, the girls are carrying their dolls and pets. Children at the home had their chores, but they also had time for fun and recreation.

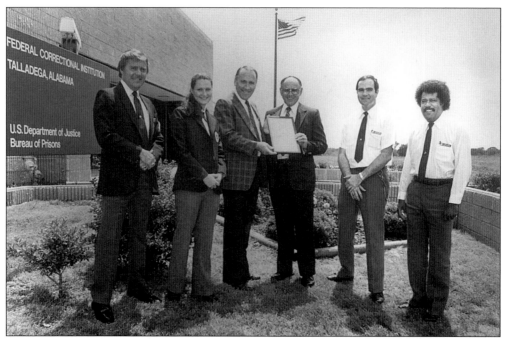

FEDERAL CORRECTIONAL INSTITUTION. FCI in Talladega was completed and entered in December of 1979. The institution provides rehabilitation for inmates and protection for American citizens. In this 1984 photograph, Mayor Larry Barton presents prison officials with a proclamation declaring Talladega a participant in National Correctional Officers' Week (May 6–12). From left to right are counselors Cooper and Jenkins, Mayor Barton, Warden Dick Rison, and officers Owen and Jones.

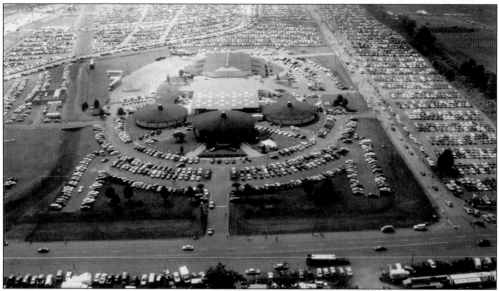

INTERNATIONAL MOTOR SPORTS HALL OF FAME. On race day, cars, trucks, vans, and RVs surround the speedway and the popular Hall of Fame. The museum, consisting of a five-building complex, is especially busy race weekends. The crowds enjoy "traveling through race history" by touring the interesting and exciting facility.

Eight
LIFESTYLE ALLEYS AND PASTIME BYWAYS

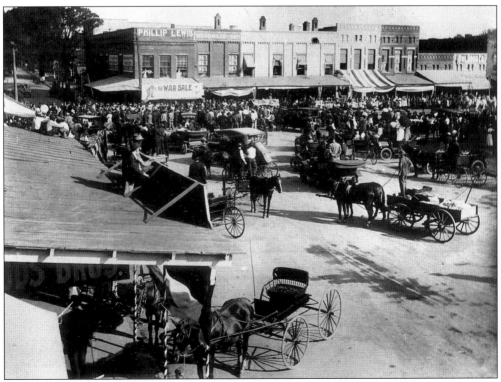

CENTENNIAL CELEBRATION. In November 1913, crowds gathered to celebrate the 100th anniversary of the Battle of Talladega. Following a parade of horse-drawn floats, speeches were made on the square. The Phillip Lewis store marked the occasion by having a "Big War Sale."

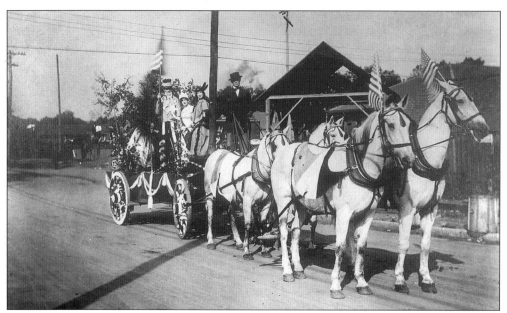

PARADE FLOAT, 1913. Drawing attention to the city's history, this float in the Centennial Celebration Parade highlighted the Native Americans, Alabama's admittance to the Union (1819), the establishment of Talladega County (1832), and "Uncle Sam." Appearing on the float were Mary Oliver, Hugh F. McElderry, Kathleen McElderry, and Lottie Slaughter. Following the parade, they posed for the picture found on page 2.

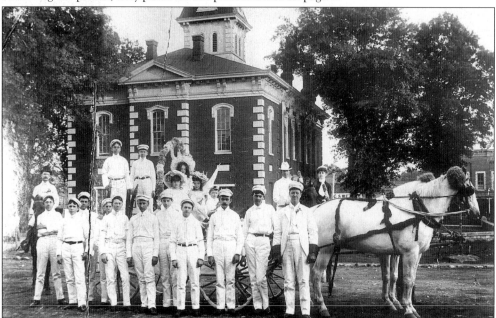

FIRST STREET FAIR. The fair was held in April 1902 under the auspices of the Talladega Fire Department. The small boy on the float is Virgil Adams Jr. R. Heine is on the horse at left. Others who have been identified are Lem Ray (third from left), Mont Lane (fourth from left), and Fire Chief Virgil Adams Sr. (last on right). Note that at this time the courthouse did not have columns on any side.

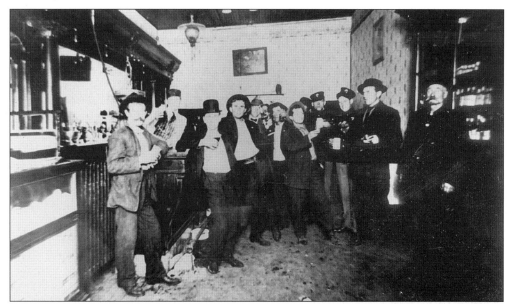

Livin' It Up. The Iron King Saloon opened in 1888 in the Chambers Building on the corner of Court and Battle Streets. It was on the first floor left, across from a grocery store on the right. Above was the Chambers Opera House where citizens enjoyed both local and professional talent. The saloon closed in 1907 after the citizenry voted for local prohibition.

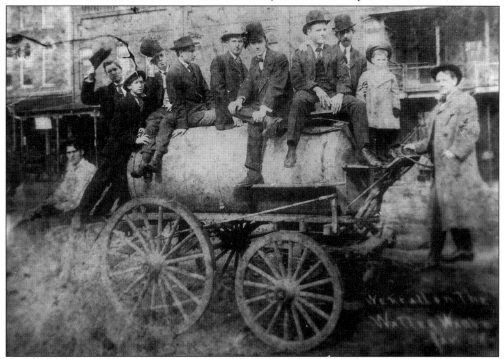

On The Water Wagon. The victory for local prohibition and the Talladega water wagon inspired this picture taken on the north side of the square. The official count of the September 1907 election showed 1,274 votes for prohibition and 227 against. Kiser Weaver, center, is wearing a white hat. J.H. Ivey and son are on the right.

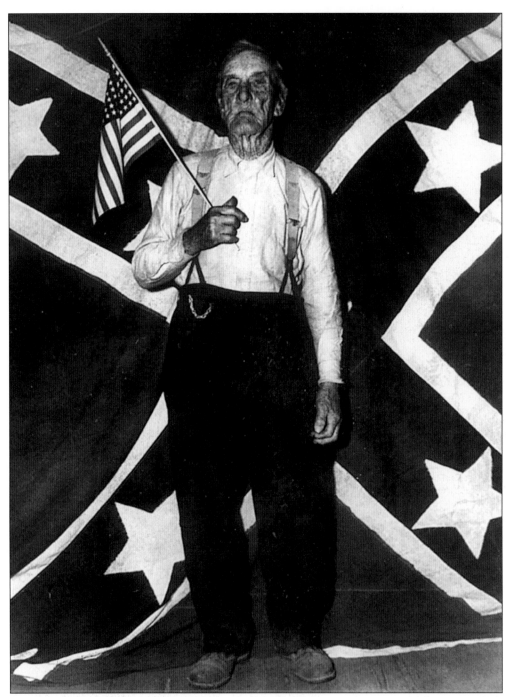

LAST CONFEDERATE VETERAN. In 1951, the last Confederate veteran in Alabama was Col. P.R. "Riggs" Crump. Born December 23, 1847, he died December 31, 1951 in Lincoln at 104. Standing in front of a Confederate flag, he holds a flag of the United States, showing his loyalty to the reunited nation. Such loyalty may have been slow in coming, however. For several years after the war, James Mallory recorded in his journal that July 4 was no longer a cause for celebration. This attitude changed with the end of Reconstruction.

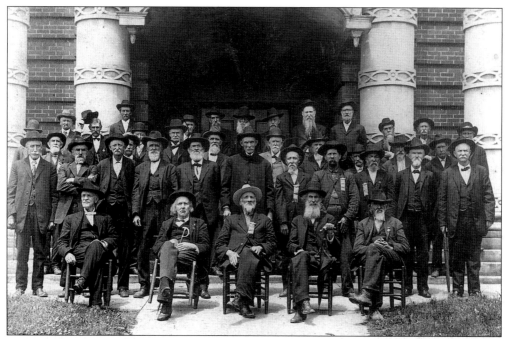

CONFEDERATE REUNION. Civil War veterans living in Talladega County in 1909 gathered for a reunion. Col. P.R. "Riggs" Crump is on the front row, seated on the left. The picture also includes James Knox Polk Jones, Henry Clay Hannah, George A. Joiner, and Dr. J.W. Heacock. The picture was taken at the courthouse.

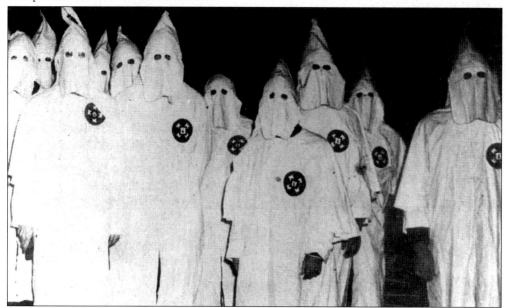

KU KLUX KLAN. The KKK was formed in Alabama in 1867, supposedly "for defensive purposes as a regulator of society." Although it had some charitable and benevolent projects, the Klan, along with its imitators, committed terrible excesses. Laws were passed in 1868 disbanding the organization. William Joseph Simmons, who became the Imperial Wizard of the revived Klan in the 1920s, was born in Talladega County.

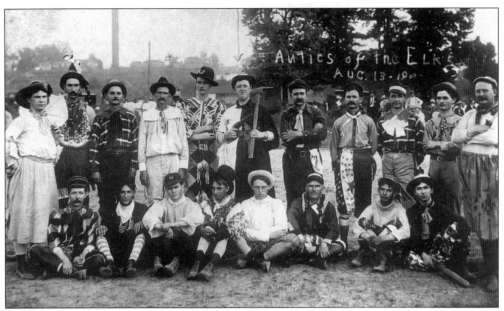

ELKS CLUB FUN. At the turn of the century, Talladega was known as "The Club Town" of the state. Most of these were women's clubs, but here the members of the Elks carry on their antics on the site of their proposed new building. The picture was taken August 13, 1900.

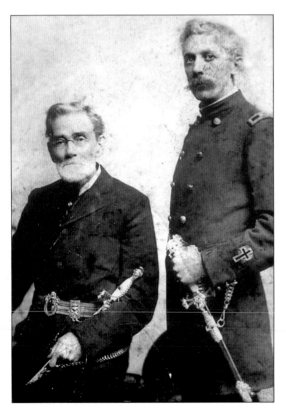

MASONS IN UNIFORM. Units of Masons were found throughout Alabama. Louis J. Wright (on right) was one of the state's most prominent Masons, serving as master of the Talladega lodge, grand commander of the Knights Templar of Alabama, grand master of the Royal Arch Masons of Alabama, and grand master of the Council of Alabama. He also served in the state legislature, as did his son, State Senator Graham Wright.

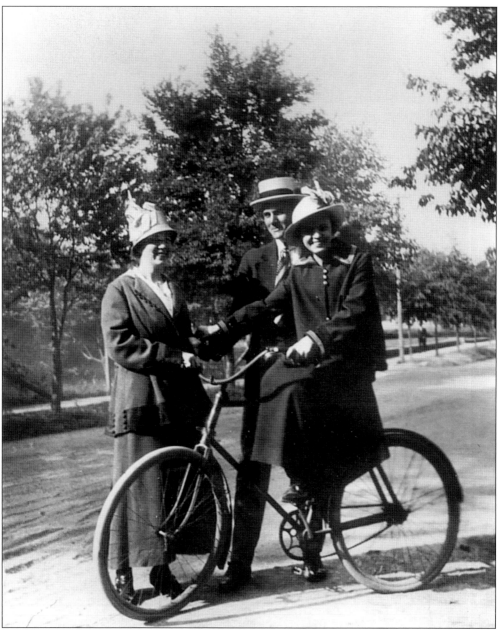

BICYCLE FEVER. Toward the close of the 19th century, bicycling became the craze for both young and old. Here Mr. and Mrs. J.D. Conner meet up with a friend on her bike. Due to pressure from pedestrians, the "Bicycle Riders" of 1895 met in the city hall and resolved that bicycle riding on the sidewalks should be prohibited.

WALDO BRIDGE. Native Americans forded Talladega Creek near the site of this bridge. Built soon after the end of the Civil War, the bridge is one of two covered bridges remaining in Talladega County. The other is at Kymulga. After their days as serviceable structures, they

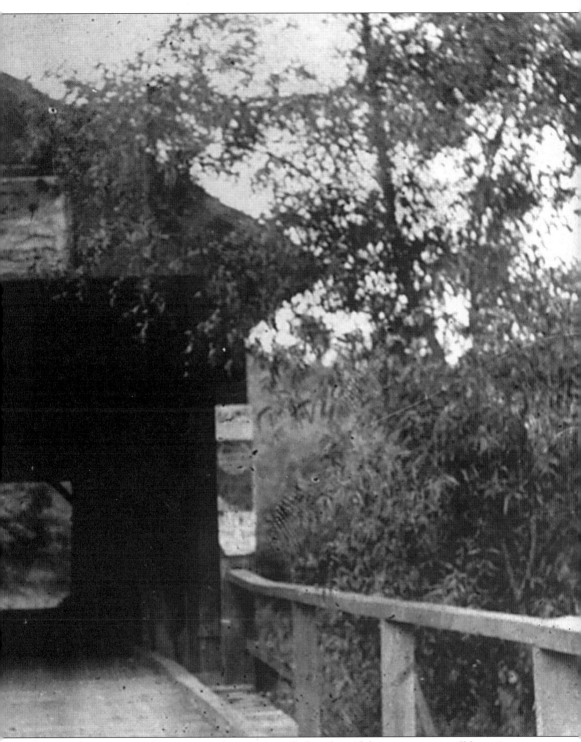

became favorite spots for picnics and recreation. Only a few Alabama counties still have intact covered bridges.

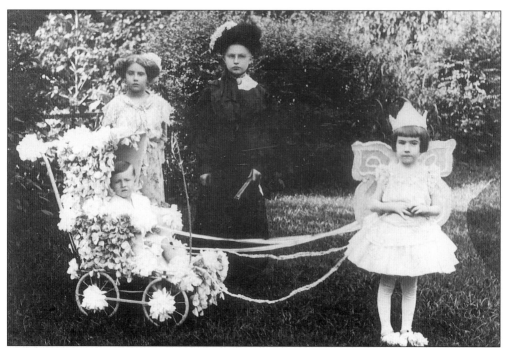

BABY CONTEST. In 1907, the ladies of the Presbyterian Aid Society sponsored a baby contest as a Sunday school fund-raiser. With each vote costing 10¢, the contest brought in $36.40 from the winning baby, George William Jones. Pictured with him are the "little mother," Mary Jones; the "little grandmother," Martha Hubbard; and a butterfly, Mary Ethel White.

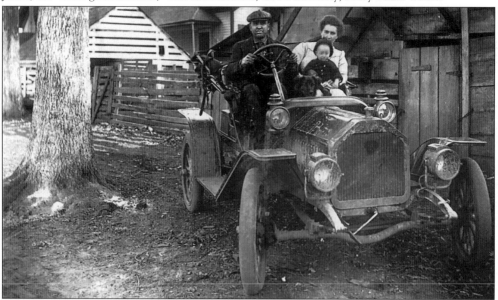

THE FIRST CAR. The first automobile in the Munford area near Talladega belonged to Dr. and Mrs. D.B. Harris. Here in this 1910 photo with their son Dan, they prepare for a ride. Dan was the father of Talladega pharmacist Blake Harris. The first female to drive a car around the square in Talladega was Lora Weaver (Ragsdale), who continued to drive around town until she was close to 100.

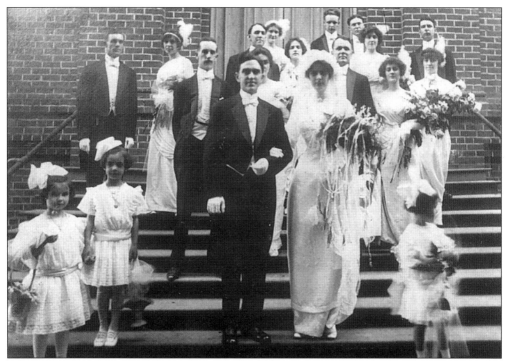

WEDDING BELLS RING. About 1913, Sarah Williams, daughter of Mr. and Mrs. John C. Williams, married Dr. Richardson. Here the couple poses on the steps of the First Baptist Church on East Street. The second flower girl on the left is Helen Wright (White).

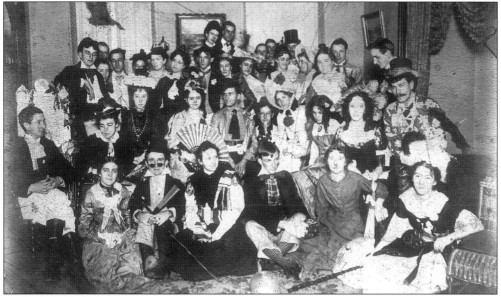

TACKY PARTY. Tacky parties were in vogue around the turn of the century. The open fan in the center of the picture is held by Lera Jones (Graham), who described the 1897 event as "the tackiest of all Tacky Parties." Stamped on the back of the picture are the words "Photo made by Russell Bros., Anniston, Alabama. Duplicates can be had for 50 cents each. For a nice frame at a low price, call on us."

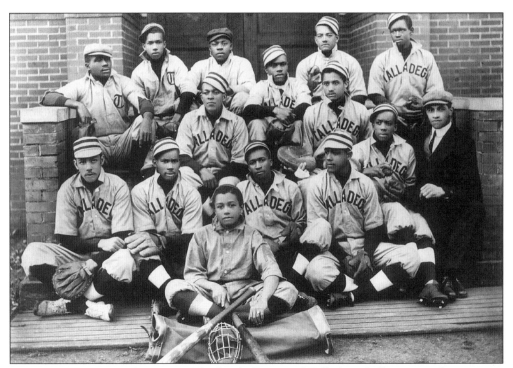

TALLADEGA COLLEGE BASEBALL. The baseball team of Talladega College poses for a picture during the "teen years" of the 20th century. Baseball, known as "the national pastime," has long been a favorite spring and summer pastime for many Talladegans. During the 1930s and 1940s, Bemiston had a superior team in the Industrial League, winning the national championship several times. "If you could play baseball, you could work for the Bemis Company."

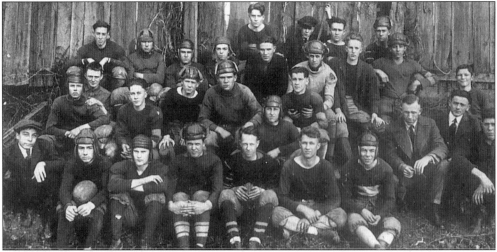

TWENTIES FOOTBALL. Uniforms were a little different in the 1920s, as can be seen in this picture of the Talladega High School team. There was little protection, including a frequent lack of headgear. This, along with rough play and the occasional use of brass knuckles taped around the fist, caused the stretcher to be brought out often. Without bleachers, fans ran up and down the field, also frequently fighting. With no grass on the field, every play ended in a cloud of dust.

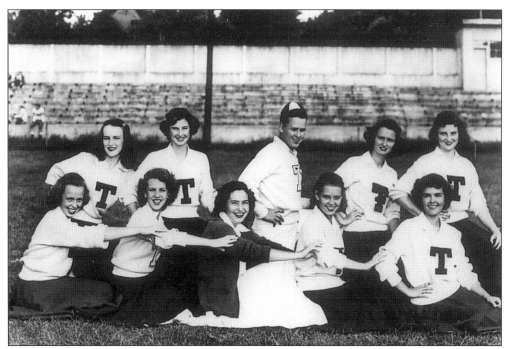

FIFTIES CHEERLEADERS. These THS cheerleaders seem to capture the spirit and optimism of the 1950s. What would a football game be without them? Today cheerleading, with all its handstands and tumbling, is considered a sport. Pictured from left to right are the following: (front row) Eleanor Lawless, Joyce Johnson, Jean Wright, Roxie Paulson, and Willa Dean Vickers; (back row) Billie Joyce Patterson, Bettye Estes, Jimmy Nabors, Joan Del Speaks, and Mary Ann Brownlow. (Photograph by R.E. "Buster" Hogan.)

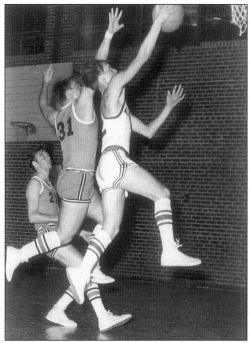

SIXTIES BASKETBALL. Robin Beverly overcomes a Lincoln defender in this 1968 game, making two of his more than 1,000 points while playing for THS. At the end of the season, Beverly was named to the Alabama All State Team. He later coached at THS, where he remains a popular history teacher. At THS, Beverly was coached by Charles "Chuck" Miller, one of the few Alabama high school coaches to have over 700 wins. At the time of his retirement, these victories gave him the second-largest number of wins in Alabama high school coaching history. In 1992, Miller was inducted into the Alabama High School Hall of Fame.

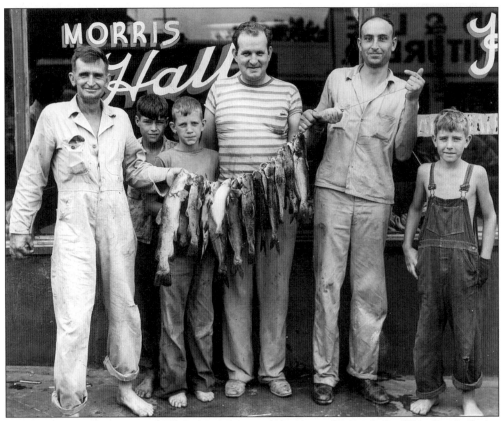

CATCH OF THE DAY. Morris Hall (center in striped shirt) stands outside his West Battle Street store along with his fishing buddies, proudly displaying the day's catch.

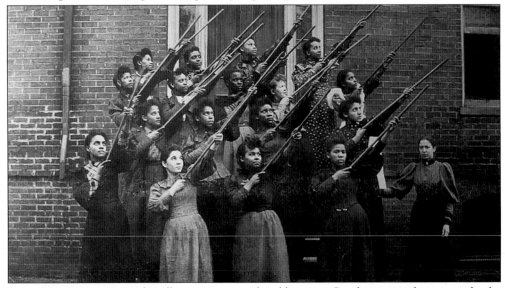

RIFLE TEAM. Learning to handle a gun is considered by many Southerners to be essential—for women as well as men. These 1895 members of the Talladega College Women's Rifle Team are instructed in their drills by Professor Frost, teacher of the classic gymnastics class.

DEER SEASON. With the area abounding in forests and woodlands, many Talladegans look forward to deer season. This father and son of the 1950s appear proud of their success.

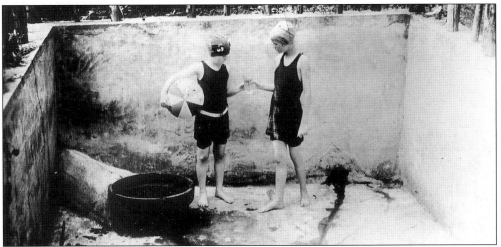

FUN AT SHOCCO SPRINGS. These youngsters are ready for a swim in the Shocco Springs swimming pool. When the pool fills, the swimmers will cool off in a hurry. The ice-cold spring water made for short swims! Shocco was a popular resort, known for its healing waters—and eventually for its wild parties. In 1947, it was purchased by Alabama Baptists, who made the rowdy resort into a religious retreat.

LIONS CLUB PARTY. In the 1930s, members of the Talladega Lions Club, known for its projects to aid the blind, enjoy a party at Shocco Springs. Seated on the left are Charles W. White and Helen Wright (White). Seated in the center is Virginia Wilson.

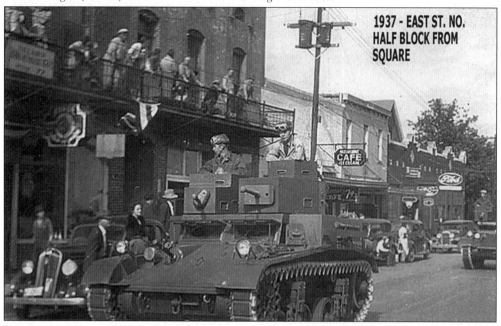

1937 - EAST ST. NO. HALF BLOCK FROM SQUARE

THE 125TH ANNIVERSARY. In 1937, a big celebration was held commemorating the Battle of Talladega. Twenty-five years earlier, horse-drawn floats, emphasizing the history of the town, had been used in the Centennial. This time tanks led the parade. Thousands gathered, watching from the streets, balconies, and store windows. The picture shows the west side of East Street North as the parade moves south toward the square. Brannons is now where the Ford dealership was.

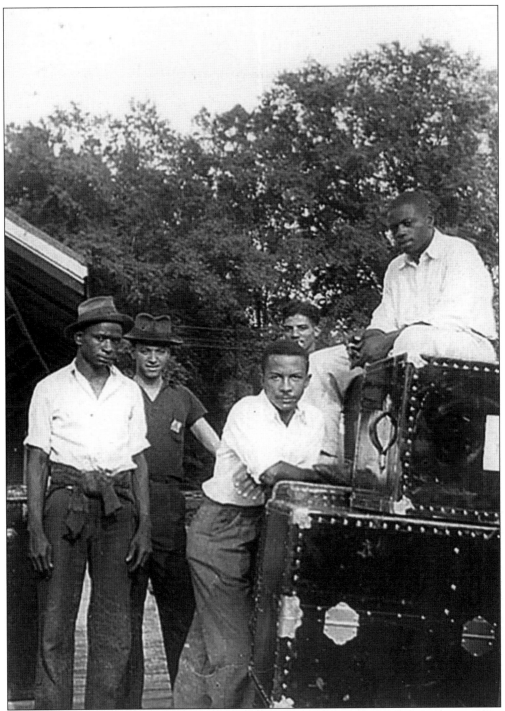

Ready For A New School Year. These 1930s Talladega College students, arriving for another year of school, seem rather relaxed while unloading their trunks. This is the time to be "laid back"; schoolwork will begin soon enough.

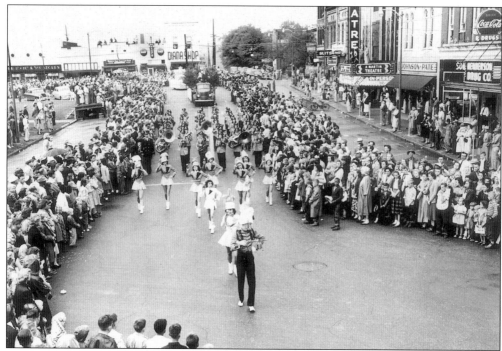

WE LOVE A PARADE. Talladega was known as "a parade town." For many years, under the direction of Virgil Chappell, the city had "the biggest Christmas parade in Alabama." Both local and out-of-town floats, numerous bands, and noted celebrities (including Miss America on several occasions) welcomed in the season. This early 1950s photograph shows the west (on left) and north (on right) sides of the square. How many stores can you find that are no longer with us?

TALLADEGA BEAUTIES. These lovely ladies are ready for the parade. From left to right are Melissa Screws, unidentified, Betty Ponder, Betty Cooley, Gail Wood, and Betty Heath. (Photograph by R.E. "Buster" Hogan.)

FIFTIES HORSESHOW. This little one receives her first-place ribbon from Margaret McAdory (on right). The event was sponsored by the Jaycees. On the left are Mary Sue Gaines and Robert Weaver, both still active Talladegans. Knowing how to "get things done," Mrs. Gaines has spearheaded numerous civic projects. Robert Weaver is known for his work with Talladega youth—and especially for his friendship and ministry with students at AIDB. (Photograph by R.E. "Buster" Hogan.)

PRIZE WINNING FLOAT. This float sponsored by the Federated Garden Clubs was a prize winner in the 1952 Turkey Festival Parade. At the time, Talladega was known as the "Turkey Capital of the World," and crowds gathered for the festival each year to see a big parade, meet celebrities like actress Lizabeth Scott and cowboy star Lash LaRue, and watch the new "Turkey Queen" be crowned. (Photograph by R.E. "Buster" Hogan.)

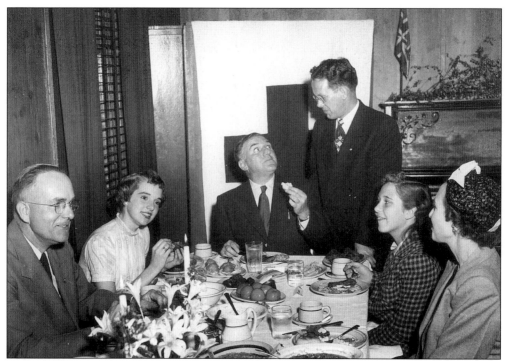

WILLIAM BENDIX AT THE PUREFOY. In 1952, William Bendix, star of the hit television series *The Life of Riley*, came to Talladega for the Turkey Festival. Here, seated at the head of the table, he dines at the famous Purefoy Hotel and chats with owner Ed Hyde. On the left are E.O. Hussey and daughter Sue; on the right are Mrs. Janice Wells and daughter Harriet. One wonders if the star came to Talladega for the festival—or to eat at the Purefoy. (Photograph by R.E. "Buster" Hogan.)

MAKING SORGHUM SYRUP. This was a familiar scene in the countryside and on the Presbyterian Home campus as well. Here, while the men attend to the syrup, the kids enjoy the sugar cane.

BIRTHDAY GIFT. James Norman Sanders prepares to receive his present for his third birthday—his first haircut. Toward the end of procedure, barber Alton Crawford gave him a stick of gum to go with the last few snips of the trimming scissors. Crawford, a popular longtime Talladega barber, knew how to deal with kids—and adults. Everyone loved him! (Photograph by R.E. "Buster" Hogan.)

MOVIES IN THE FIFTIES. Long skirts were worn by moviegoers back when this photograph was made around 1950. At that time, the Martin Theatre had *Ritz* on its waterfall (later removed and still later restored). There were two other theatres in town: the Paramount on North East Street, and a drive-in on the Lincoln Highway. Admission price was 15¢ for children 12 and under; those over 12 paid the high price of 45¢. Some "short folks" in town remained 12 for several years.

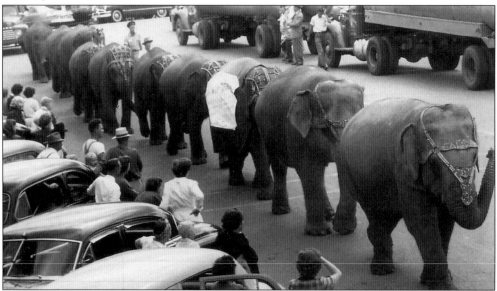

UNUSUAL TRAFFIC. One does not see elephants on the square much any more, but they were there in the 1950s when the circus came to town. Local boys would get passes to the circus for washing the elephants. These same industrious boys would cut a lawn on the way to the swimming pool so they would have the quarter needed to swim.

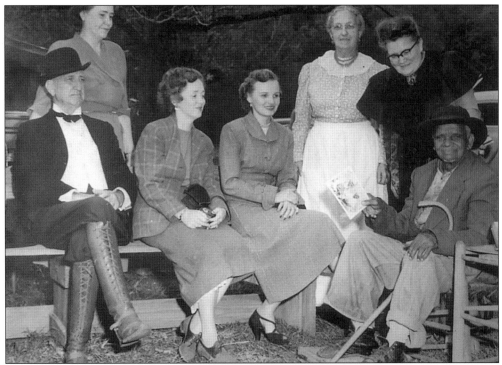

JACK RIDDLE AT SOCAPATOY. Jack Riddle (on right) was born a slave in Atlanta and was brought to Talladega County in 1841. He came to be loved by all who knew him. He died in 1952 at age 111, leaving his wife of 82 years, Josey. She was widowed at the age of 98. At the celebration pictured, his Waldo neighbor Maude Owens leans over his chair. She owned a florist business in Talladega and was the developer of Lake Socapatoy.

PETE'S CAFÉ. The café was on the south side of Battle Street, just off the square. It was owned by Pete Hontzas, a popular Greek immigrant with a just as popular wife, Assimina. In the picture, Pete stands at the right. Just up the street was the Dixie Café. The year evidently was 1962, when Ryan de Graffenried, a young Tuscaloosa attorney, lost in the gubernatorial runoff to George C. Wallace.

MAID OF COTTON AT MAYOR'S HOME. When the 1952 Turkey Festival was held, Catherine Bailey, the Alabama Maid of Cotton, visited in the home of Mayor and Mrs. Wallis Elliott. Pictured with her are "little" Wallis and "little" Sydney. (Photograph by R.E. "Buster" Hogan.)

Nine

A THOROUGHFARE OF
TALLADEGANS
EXTRAORDINAIRE

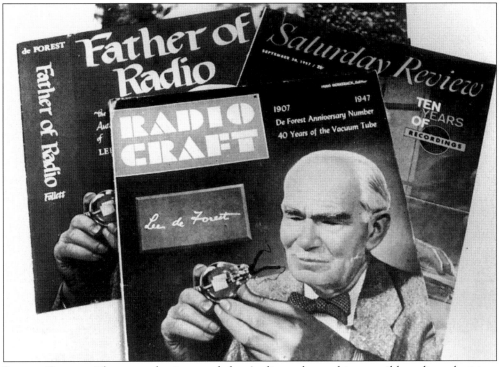

LEE DE FOREST. The man who invented the Audion tube, making possible radio, television, sound pictures, and long-distance telephoning, grew up on the campus of Talladega College, which his father Henry Swift De Forest served as president. (The father capitalized the *d*; the son did not.) Known as the "Father of Radio," Lee was an inventor with over 300 patents. De Forest and the others pictured in this chapter represent the many, many Talladegans who have lived extraordinary lives, making life better for others.

(*above, left*) **JABEZ LAMAR MONROE CURRY.**
Making outstanding contributions in the
fields of government, diplomacy, religion,
and education, Curry was the first Alabamian
chosen to represent the state in Statuary Hall
in the National Capitol.

(*above, right*) **MARIA FEARING.** In 1871, at age
33, Maria Fearing learned to read and write
at Talladega College. A quick learner, she
joined the staff of the college. Later she went
to Luebo, deep in the continent of Africa,
where she started a school for homeless girls,
teaching basic living skills and the Christian
faith to hundreds.

(*below, left*) **DR. JOSEPH H. JOHNSON.** In the
1850s, a medical doctor named James H.
Johnson moved to Talladega. Here he
founded the Alabama School for the Deaf,
with his younger brother William Seaborn
being the first pupil. The first year he fed and
cared for 21 students, meeting total school
expenses on $85 per month. Johnson gave
AIDB the start it needed to become one of
the leading institutions in the world for the
sensory impaired.

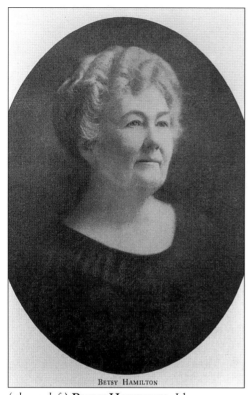

BETSY HAMILTON

(*above, left*) **BETSY HAMILTON.** Idora McClellan Plowman Moore, known by her pen name "Betsy Hamilton," won wide acclaim for her dialect sketches of plantation life and the Alabama "cracker." Highly successful as a writer and lecturer, she vied with "Bill Arp" and "Uncle Remus" for popularity.

(*above, right*) **JOSEPH B. GRAHAM.** J.B. Graham, superintendent of both the city and county schools, was a leader in the Southern education awakening at the turn of the century (1900). He served with distinction in both statewide and south-wide positions. Graham School, built in 1904, was named for him.

(*below, right*) **JULIA LYDE.** The only Alabama nurse to give her life in service for her country in World War I was Julia Lyde. She was awarded the *Croix de Guerre* for extraordinary performance of duty under fire in France.

117

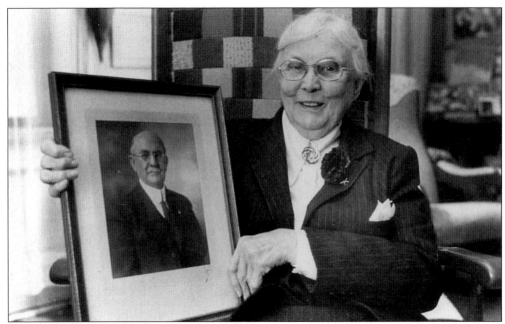

WILLIE W. WELCH AND DR. SAMUEL W. WELCH. "Miss Willie," local historian, genealogical researcher, and longtime librarian, holds a picture of her father, Dr. S.W. Welch, co-founder of the Talladega Infirmary, president of the Alabama Medical Association, and head of the Alabama Department of Public Health. During his tenure, the Bureau of Vital Statistics was formed and the Bureau of Sanitation Engineers was established, making Alabama "a model of countless health measures."

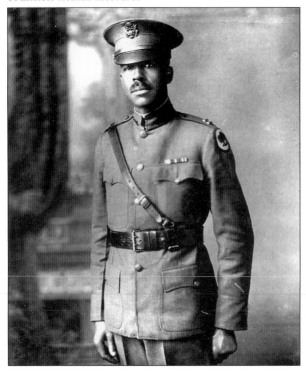

DR. ELISHA HENRY JONES SR. Dr. Jones, said to be the first doctor to successfully sew an open wound in the human heart, graduated from Talladega College in 1904 and received the M.D. degree from the University of West Tennessee in 1909. A member of the Buffalo Soldiers, he rendered valuable service during World War I. He was the first doctor in Talladega to have an X-ray machine in his office.

SIGNOR GUISSEPPI MORETTI. Moretti was an Italian sculptor who lived in the Talladega area around the turn of the century. Owner of the Moretti Statuary and Monument Company in Talladega, he was vice president of the Talladega Marble Company. He is best known as the creator of Vulcan (on Red Mountain in Birmingham), the largest cast iron statue in the world. Here he is pictured with a model of the famous statue.

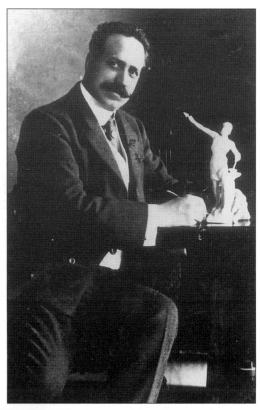

IDA WALLIS ELLIOTT. Founder of Ida Academy (later Idalia School), Ida Wallis Elliott started Eliott Tours, which became one of the nation's largest tourist agencies. She displayed in her Talladega museum items she collected from around the world. A civic leader, she founded the Women's Chamber of Commerce and numerous garden clubs. She personally bought and planted over 1,000 dogwoods and crepe myrtles along the streets of Talladega. These are still enjoyed each spring and summer.

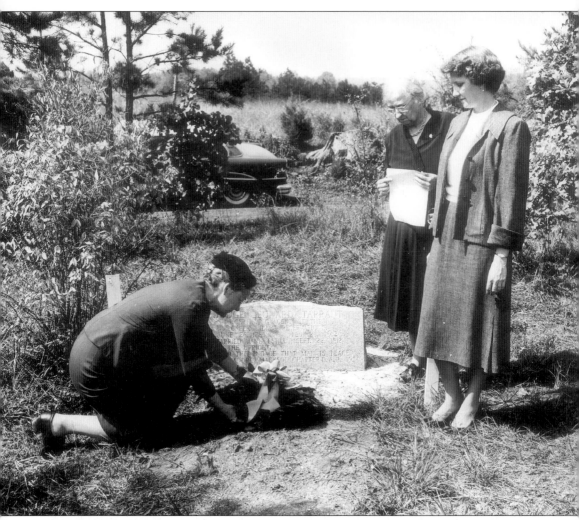

MARIA WHITSON, E. GRACE JEMISON, AND MRS. NAUBURN JONES. These ladies are preparing a monument to Judge Tarrant, Methodist minister and early land officer in Talladega County. Miss Whitson was the first female to receive a degree in electrical engineering from Auburn University and the first woman elected to the Talladega City Council. Miss Jemison, local author and historian, wrote *Historic Tales of Talladega.* Mrs. Jones continues to make civic contributions in a variety of ways. Other past "Talladegans Extraordinare" include R.E.B. Baylor, for whom Baylor University is named; Dr. Lewis A. Boswell, who had patents on a "flying machine" before the Wright brothers; John Tyler Morgan, influential U.S. Senator; Maude McLure Kelly, the first Southern female lawyer to practice before the U.S. Supreme Court; Lewis E. Parsons and Joseph F. Johnston, both Alabama governors; and Gertrude Michael, star of stage and screen. Many other extraordinary Talladegans—including professionals like physicians C.L. Salter, L.D. Graves, and James L. Hardwick; ministers Clare Purcell, J.M. Thomas, and William Crowe; and educators Mildred Maxwell, Zora Ellis, Hal Henderson, and Evelyn Houston—are featured in *Outstanding Talladegans of the Centuries* published by Talladega Homecoming 2000. (Photograph by R.E. "Buster" Hogan.)

Ten

NASCAR's

FASTEST TRACK

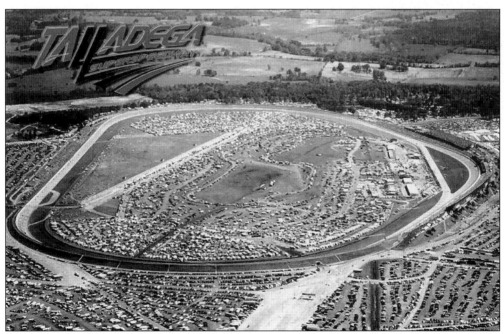

TALLADEGA SPEEDWAY. The "biggest, fastest, and most competitive speedway in the world," Talladega Speedway opened its gates in September of 1969 as Alabama International Motor Speedway (AIMS). Known for photo finishes, with records being set for both speed and lead changes, the track has provided the ultimate in racing excitement for over 30 years.

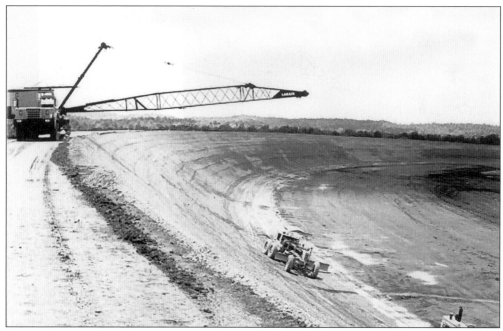

CONSTRUCTION BEGINS. After considering numerous sites, and working with Mayor James L. Hardwick, city commissioners Hubbert Hubbard and James Shadrick, O.V. Hill, and other Talladegans, NASCAR president William H.G. "Bill" France and his associates decided on Talladega as the place for a new raceway. Located in a beautiful spot in the foothills of the Appalachians, the site provided plenty of land (2,000 acres), interstate access, and a large population base within 300 miles. Construction began on May 23, 1968, and the first race was held 16 months later on September 13, 1969.

WOMAN AT WORK. This attractive construction worker seems to be enjoying her job. She and her fellow workers built a track 2.66 miles long and four lanes wide, designed as a tri-oval, similar to Daytona's "D" appearing track. The speedway was located on airport property belonging to the city, and the Airport Board was instrumental in securing it. Members included George Jones, Joe Wallis, John Norman, John D. Cork, Winston Legge, John Barksdale, and Byron Boyett.

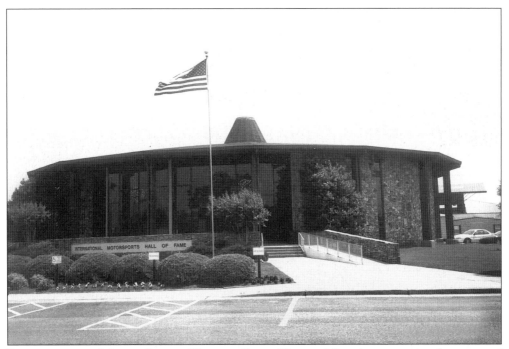

INTERNATIONAL MOTOR SPORTS HALL OF FAME. The world's only international museum of racing, the complex houses cars raced by "the legends," mint condition muscle cars, antiques, classics, and memorabilia dating from 1902. In addition, it is home to eight different Halls of Fame and an impressive research library. All the pictures in this chapter were furnished by librarian Betty Carlan, a racing enthusiast made for the job.

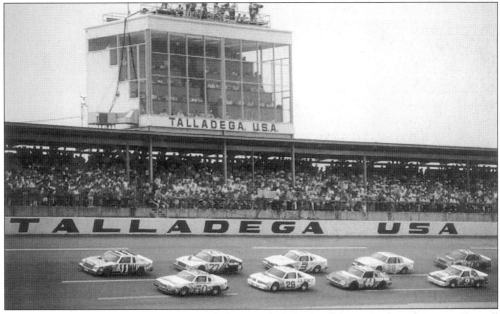

TAKING THE LEAD. Sportswriters record the excitement—and fans stand to cheer—as Darrell Waltrip (11) and Geoff Bodine (50) take the lead in the 1982 Talladega 500. Waltrip finished first in this August race, having already won the Winston 500 in May of that year.

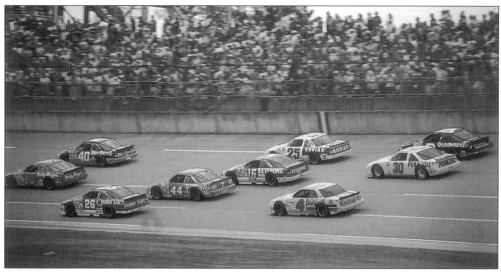

FOUR -WIDE RACING. With the contest ever so close, fans witness four-wide racing in the tri-oval during the Winston. With the track banked 33 degrees on each end, and with 18 degree banking in the tri-oval, the layout has provided some of the most competitive racing in history. The backstretch is nearly 4,000 feet long, enabling stock cars to reach speeds of over 220 miles per hour in competition.

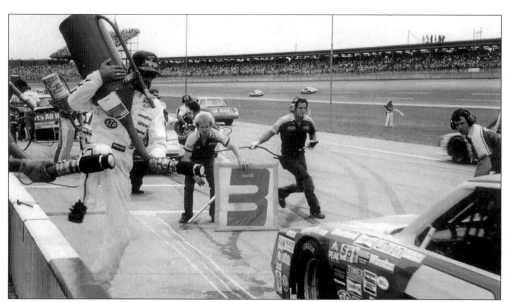

IN THE PITS. Dale Earnhardt's crew springs into action, helping bring victory. As two seconds on the track is the length of a football field, many races are won or lost in the pits. Just one slip and it is all over!

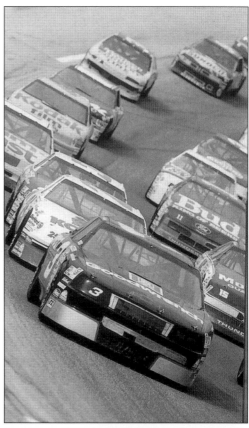

ON THE CURVE. Rounding the 33 degree embankment, Earnhardt (3) now leads the pack. Known for "seeing air," from seventeenth place he came through the middle in the last two laps to take first place.

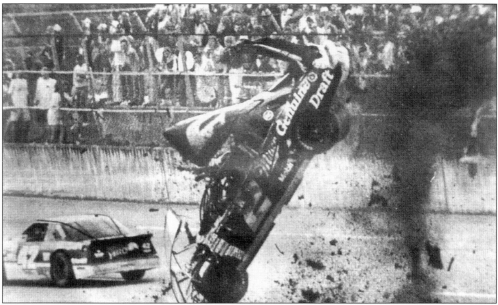

NOSEDIVE. Rusty Wallace takes a nosedive in this 1989 wreck. Amazingly, he was not hurt and was able to walk away. After Bobby Allison's earlier wreck, when stock car parts flew into the stands, a new catch fence was put in place.

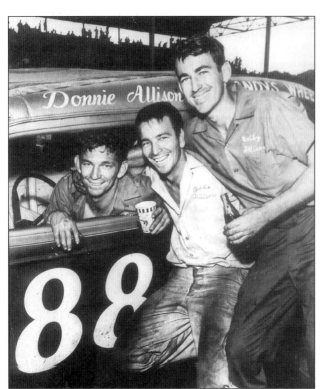

THE ALLISON BROTHERS. Eddie Allison (center) turned wrenches on his brothers' race cars when they regularly campaigned on the short tracks of Florida and Alabama. They are Donnie (left) and Bobby (right). The next generation, Davy and Clifford, continued the winning tradition. The Allison name was thus big in motor sports in four decades.

THE JOY OF VICTORY. Dale Earnhardt sprays champagne in Victory Lane after winning the 1999 Winston 500. Such heroes, and the excitement they generate, bring more sports fans to Talladega (well over 200,000 to a single event) than to any other sport event in the state—including the Alabama-Auburn Iron Bowl.

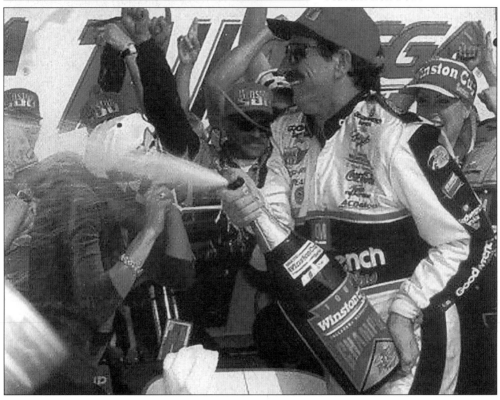

EARNHARDT'S LAST WIN. Dale Earnhardt was the dominator of the Talladega track, winning the Winston Cup here ten times. In the 2000 EA SPORTS 500, he was eighteenth with just five laps remaining, but he stormed to the front, claiming victory. Here he celebrates what was to be the last win of his career. Sadly, he was killed in a Daytona race only a few months later (February 18, 2001).

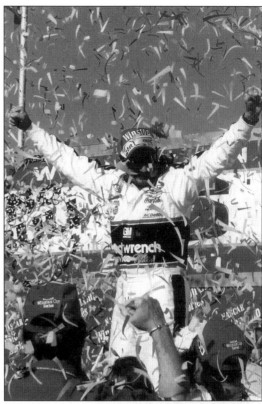

A PHOTO FINISH. Perhaps the greatest 1-2-3 finish in motor sports history occurred in the 1981 Talladega 500. In the last 500 yards, rookie Ron Bouchard used the draft to slingshot around Darrell Waltrip and Terry Labonte, winning the race by less than a foot. Labonte commented, "Talladega is the only place we run where we finish closer than we start." Although this photo finishes the book, it does not finish the story—for there are more images to recall, more anecdotes to relate. In fact, each new day Talladegans add intriguing episodes to the "tale of Talladega."

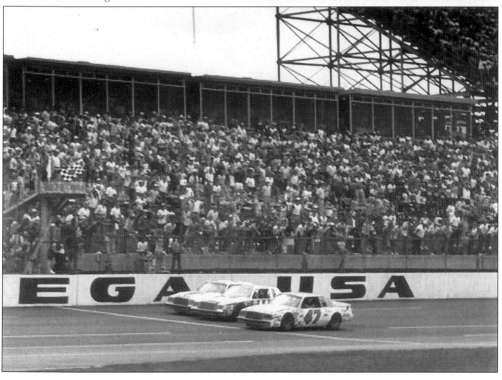

ACKNOWLEDGMENTS AND SOURCES

In the early 1980s, a group of dedicated local women undertook the task of collecting photographs from Talladega's past. Many citizens cooperated in the effort, and over 400 pictures were accumulated. They were identified, categorized, and put on display at Heritage Hall. A pamphlet, *Traces of the Nearby Past,* was printed to briefly describe each picture. Among those leading in this project were Frances S. Upchurch, Barbara Sweat, Martha Williams, Mary Nelson, and Meg Wallis. Without their thorough work, the completion of this book would have been impossible—at least in the period allotted. Other wonderful photographs, mostly from the 1950s, were preserved by former librarian "Miss Willie" Welch. Many of these were taken by Talladega freelance photographer R.E. "Buster" Hogan. Librarians and personnel at various institutions—Talladega Public Library, Talladega College, AIDB, the Presbyterian Home, Shocco Springs, and the International Motor Sports Hall of Fame—assisted in providing photographs and information. When called upon, many individual citizens contributed pictures. Van Blankenship and Jim Smothers made copies of some of the photographs, which numbered almost 700 when the collection time ended. Unfortunately, due to limitations of space, less than one-third of these could be included in the present book; however, Heritage Hall will eventually utilize all the photographs.

The board of Heritage Hall has been very supportive, and its director, Tommy Moorehead, has been a most helpful collaborator. Sean Flynt, author of *Samford University* in the *Images* series, made valuable suggestions, and editor Katie White at Arcadia patiently guided me through the publication process. Ken Gutherie, teacher at Talladega High School, and Lela Locklin, former THS instructor, each painstakingly proofread parts of the manuscript. My greatest encourager—and most useful critic—has been my neighbor and friend Roscoe "Rocky" Brook. He, along with historian William "Bill" Snell, originally suggested the project; and he has seen the book through to completion.

Other historians have recorded Talladega's past, and their works have often been consulted. The reminiscences of Mrs. L.M. Taylor, J.L.M. Curry, and J.W. Vandiver were interesting accounts. The scrapbooks and newspaper articles of local historian Vern Scott contained intriguing stories. Books utilized included *Fascinating Talladega County* by Randolph F. Blackford; *Historic Tales of Talladega* by E. Grace Jemison; *Out of Silence and Darkness* by Robert Hill Couch and Jack Hawkins, Jr.; *The Heritage of Talladega County, Alabama* prepared by the Heritage Book Committee chaired by Betty L. Carlan; and *Outstanding Talladegans of the Centuries* published by Talladega Homecoming 2000, directed by Mike Mitchell. I am truly indebted to these earlier preservers of the past.

I would be remiss if I did not thank my international students, Alexis Bertholet, Christian Buschhuetter, and Michael Leipold, who allowed me to give time (including their computer hours!) to the book—time that otherwise would have gone to them. Finally, my thanks is extended to the many good people who make Talladega a wonderful place to live. They are insuring a rich heritage for the future—and to them I dedicate this book.

—Walter Belt White